SCHEMATA

PROGRAM: WRITTEN, COMPILED, TESTED, VALIDATED AND EXECUTED

A BOOK OF FAKE STORIES WRITTEN AND ILLUSTRATED BY
PAUL ANDERSON

ALL WRITTEN WORK COPYRIGHT © 2007 PAUL ANDERSON

ALL ARTWORK COPYRIGHT © 2007 PAUL ANDERSON

BEGIN

INITIAL PROCEDURES

WELCOME

EQUAL OPPORTUNITY

Do not be alarmed, take your time. Left, right, or? One way is more correct as befits your potential!

STORY

Pleasure was not the goal of the afternoon. True, Smith was very pleased at the resolution of the session. Power was at stake; Smith had acquired it in abundance. Confident all would bow and scrape before, Smith pushed through the plans that would inaugurate the final part of the jigsaw. Smith was now on the threshold of omnipotence. How could Smith fail now?

The floor gave way; Smith had only micro-seconds of glory at the crowning moment. The triumphal smile dissipated as nature's wondrous hand pulled the plug: Smith fell gently to the centre of the world.

STORY

The beer garden was flooded with drinkers and noisy children. It was warm, a balmy day, I was looking for quiet refreshment away from town smells and dirt. The countryside was positively inviting yet, on arrival, I began to reconsider the validity of my driving efforts. Every hostelry was crammed of the very stuff I wearied against. Windows full of pot bellied, pint drinkers; tables overflowing with squabbles and lager, I dreaded going another mile. I went home and what a pleasant surprise, my local by the town hall, was empty. The landlord looked miserable; he blamed the good weather for his lack of trade; I blamed the weather for my good fortune.

STORY

Julius was a clever man; he knew a thing or two. He was never caught out by anyone. Even the most astute at the institute could not falter his wit. Two Sunday's ago Cicero came to town dressed in a vibrant gown. Now Cicero was not a man to be messed with, he would tell you where to go, if he thought it so. Julius and Cicero went for a bathe at the local hot spring. Relaxing with feet in water Cicero asked Julius many probing and vexing questions. Julius was not stumped by any of Cicero's jibes. He replied, quite calmly, "My dear Cicero, if you do not know the answers to your questions, truly, you are a seeker of knowledge. And, I must say, I am flattered that you think I can answer. Do you think I should tell you the answer to any of your questions?"

METRO

1:
All these people have a specialization in at least one subject.

Mrs. Slobin is an expert at making tea; especially with her samovar.

Mr. Vostock is very good at reading, particularly English books and, works as a translator for the 2^{nd} Commissariat, 3^{rd} Division, 4^{th} floor of the new Putin Building just off Red Square. He does a fine job, is paid well, he reads Ian Fleming books and translates the text to Russian for consumption in Siberia.

Miss Smitts works as a professional escalator servitor. It is her day off and, as usual, she enjoys using the very item she maintains so well. Miss Smitts is on her way to her sister's apartment just outside Moscow. She takes great pride in knowing that her work enables millions to descend into the bowels

of the metropolis every day using the Metro Web for their individual endeavours.

Goran is an author of books. He is a technical writer as well as a top flight Astro-Physicist. Goran travels daily on the Metro from his flat in Putin Building to the top secret space research labs across on the East side of Moscow. He needs new glasses, but will make do for two more years.

2:
Again the crew descend the depths for the morning's torturous journey to work. Tubes run here, run there, a network of underground complexity fit for a complex city.
"Here we go again", says Ivan to himself, "on our way to Hell!"
Ivan works for the Moscow Bank of Commerce; he is a clerk, senior clerk to be precise and, soon to be junior manager. Ivan has become ambitious since Capitalism reared its ugly head in 1990. Ivan wanted the *best*; his background was poorer than poor, living with four families in one flat. Mathematical skills gained him entry to the newly opened Commerce Bank. He was set for a career. He began to make life easier for his family. First, they moved to a new three-bedroom apartment with hot water and then, last year, he bought a dacha in the southern outskirts of Moscow.

Ivan enjoyed his bank work – he hated getting there and back, day in, day out, the Metro was such a chore! Friday last he had returned from a business trip to London; after using The London Underground the Moscow Metro did not seem quite so bad. Even so, next year he would buy his first car when commencing his predicted post as junior manager. In five years he plans to be a director – he will buy a bigger car then.....

3:
The efficient use of city space both above and below ground was paramount to the expansionist ideas of Mayor Bulge. Mayor Bulge wanted "his" city to be the biggest, the best, brightest, most loved, most visited, most exotic and, have most efficient public transport, in the world. This was achieved by a beautifully integrated roadway and over ground transport network alongside a quality underground railway system servicing all quarters.

Today we travel with Bill on his journey to work. He is a daily user of Mayor Bulge's underground railway system, known as the Metro. He descends at Park Avenue West and 13th Street; always with his head in a book. Goodness knows how he negotiates his way to his destination but, from start to finish, he manages to read at least five chapters. Bill boards his train, travels the stops, alights, makes his way to central interchange where he boards the Out Towner for Oakridge. On arrival Bill alights, finds his way to the escalator, shows his ticket and, leaves Oakridge station. He walks

two tree lined blocks to Astarte Building, the doorman salutes whilst opening the door for him. Bill ascends in his personal elevator to his penthouse office 80 storeys above ground level. Here he places his beloved book on his desk where it will wait until 5 P.M., home time.

Life sure is good in Mayor Bulge's city.

THE FOOTBALL FANS (FOR WANT OF A BETTER NAME)

It was hot, so hot the crowd could not wait for the match without refreshment.

When the players ran onto the pitch, where were the fans? We cannot play without fans.

We know the fans were seeking refreshment. Soon they will return to the stadium then it will be OK for the players to commence their game. The referee, who was feeling a little faint, suggested that the players march back to the changing room; he would call them when the fans returned.

True to his word the fans returned, very refreshed and ready to keep the players cool. On hot days it's good to have fans.

CAMELS ON A RIDGE

There's a call in the desert,
A call from the sun,
Descending into night.

Dunes, constant,
In their pervasive abstraction,
Of energy.

Limbs, limp, power drained feet,
Slipping away,
From expected surety.
Efforts doubled and redoubled,
To achieve a simple mile.

There's a call in the desert,
A call for rest and
Refreshment after,
A stunningly hot and,
Difficult day.

A DELIGHTFUL VISIT

A few stars past the last galaxy lay a most singular planet. Spinning, for all its worth, tied in an elliptical orbit to a blue sun.

The planet, known as First and Last, is the well-known tourist location for those who want something just that little bit different. Don't get me wrong, within the whole cosmos one can find every kind of distraction imaginable; First and Last is not exceptional in what it offers, only in the surroundings in which it is offered.

First and last is the only planet in the entire universe that has absolutely no gravity. How this came about no one can explain, apparently it is a scientific impossibility. Yet there it is on the edge of nowhere delighting billions of visitors, pleasure without ties.

Of course some recreational activity requires certain restraints and with clever use of mini-jets every whim can be met.

One of the favourite sports on First and Last is 3D Football. The most skilled players use only four mini-jets. The absolute stars of the game provide thrills to the trillions of viewers, universe wide (and multiverse but that's another story).

Many games, of a more personal nature, this reporter will leave to the imagination.

Eating and drinking pose no problem, all restaurants, hotels, cafes etc, provide gravity booths at which victuals can be enjoyed under normal conditions.

You are probably asking yourself why people visit such a way out place just to experience non-gravity activity when, in truth, non-gravity can be experienced anywhere in space? The answer, briefly hinted at above, is simple: Beauty with a capital B. Nowhere in the whole of creation is the sheer wonderment of First and Last surpassed. Just to witness the majesty of this planet is a life-changing event.

So you see, First and Last caters for every taste. The limit is your wallet.

RED TEMPLE

The Red Temple of The Red Sun, Anjapix, was about to succumb to a new lease of life.

God Emperor Anthony Blagg, in a cosmic wide broadcast three years ago, announced that the Red Temple would become the centre of a Universal Cult of Healthism.

Healthism, as you know, has long been with us but not in a standardised form. The many factions of Healthism have been at each other's throats for many decades and Emperor Anthony decided, on a whim, that this must stop.

Emperor Anthony has laid down elaborate and totally un-thought-out plans for the Cosmic Wide acceptance of the Anthony Blagg Principal of Healthism.

Tony says:
- It is good for you to attend a Healthist temple.
- It is good for your body, mind and spirit to immerse itself in the one true version of Healthism.
- The One True Version of Healthism is my version and all of you, the whole cosmos that is, will follow this true way if it is the last thing I, or you, do. You will do as I say!

He continues:

- Every ten years you will make pilgrimage to Anjapix and you will receive Health at the epicentre Red Temple of the Red Sun.
- Ideally you will make fifty such pilgrimages throughout your long lives.
- Health be with you all!

So it came to pass and, surprisingly, billions of followers of Healthism took up the Emperor Anthony Blagg True Way of Healthism.

When looked at from an outsider point of view it is not surprising at all that the majority of peoples of the cosmos availed themselves of the "True Healthism". Emperor Anthony had commissioned the Navy Space Corps to coerce the masses into enthusiastic acceptance.

True Healthism, according to Anthony Blagg, became everyone's favourite …especially at gunpoint.

THE CLOWNS OF VERMONT

Yes, these guys get around but Vermont is their home state. They live in a small village called Little Homestead. They have known each other since childhood, they are good friends.

The Troupe, as they call themselves, first decided to do clowning in their teens. And, after graduating from college, decided to become a professional act. They found a clowning agent in the city who, with much gusto, found them work locally, nationally and internationally.

The Troupe became famous and every year for two months they would go back to Little Homestead visiting family and friends. Sadly, for ten months of the year, the Troupe's success keeps them away from their wives and children. It is hard to go on tour again but, when home, they do celebrate in style and it makes for good memories to carry on the long road.

As they get older The Troupe begin to realize that Clowning is not so popular anymore. Their audiences are dwindling, demand diminishing. Within ten years their act folds and they travel back to Little Homestead. New lives are waiting to be built, I am sure they will succeed.

THE QUEUE

Queue 1:

The Part:
We all want the part; only one of us will get it, maybe not one of us here today. These auditions go on all week and perhaps next week. Maybe the director will find his/her match in the local supermarket whilst he/she is shopping for the evening meal that she/he will prepare in the loneliness of a film set caravan.

Bill:
I'm not too worried about the part, if I get it I get it and good luck to the rest of them. I see men and women here, why, I thought it was a male part. I guess the casting manager likes to keep options open. It is a one-person play, male/female no problem, I suppose.

Jane:
I left art college in 1976, took up acting ten years later, the art world was not ready for my creations. Truth is the art world stinks; I'm glad I'm out of it! This acting lark pays the bills now. I am good at it, always in work, if this audition fails I've got another one tomorrow with the Krackow Players.

Conrad:
What a name, Conrad, I'll change it to Alexei next week. I have had a few jobs since arriving in England, all chorus line. This is my biggest trial yet. If I get this job I'm made; so my agent tells me! She sends me along to every

audition saying, "You'll be made if you get this part." Chorus line pays the rent but….it don't make me famous!

Queue 2:

Bill is waiting (version one):
Bill has been waiting for five days, he is getting a little distraught. Bill is not a great one for losing his patience but it has now got to the stage where his creative thinking has run out of steam. This is unusual for Bill; he is a professional queuer and, as such, has developed a very sophisticated thinking system to pass the time. He was considering leaving the queue, he knows if he does that he may have to wait another five days to reach where he is now. This would not be good. It is known, in current society, that he who waits longest gets the goods.

The rewards for the wait are huge; the last person remaining in the queue will receive a house with garden and running water. Not only that; a choice of fridge and free, fresh milk for a year.

Bill reminded himself of the rewards for waiting and calmed down. The big issue about queuing is comfort. Personal comfort. There were no facilities for 500 hundred metres and if the queue is left, for whatever reason, one has to go back to the end.

You can imagine; Bill had not left the queue for days; there were only two people in front of him, he was nearly there….

Bill is waiting (version two):
Bill was still waiting. Nearly six days now.

Bill was very clever he had a rucksack full of provisions that would last seven days. He also had a small but discreet toilet system about his person. Meaning he could remain comfortable, never leaving the queue and losing his place like so many of the others had done.

The trick with this queue was to stay in it, no matter what, no matter how long, just stay with it. You will get there if you persevere. Bill had learned from years of queuing, that the only way to win in a queue was to stay in it and be prepared. The longest queue Bill had been in lasted four weeks. He knew this one was a seven-day queue; he was certainly going to get to the end.

And surely he did. He interviewed for the post as Director of Queues and three weeks later received confirmation, in writing, that he had been offered

the said position. His application and determination was of such quality that he was put on the highest pay band. Lucky Bill.

POLENTA FERMENTA PRINCIPIA

The firm "Fruit, Vegetable and Meat Products" was experimenting with new drinks in mushy form. Ingredients for "Mushies", as they became known, included bananas, polenta and eggs alongside many other usual fruits and vegetables.

Some of the new products were designed for non-vegetarians. "Pie Mushie", was to become an all time favourite especially with shepherds. After a long day in the hills a warm billy of "Pie Mushie" set them up a treat.

Professional bicycle riders from all round the world enjoyed "Egg and Meat Mushies" whilst waiting at international checkpoints during a race. The convenience of sucking self-heating bottles was much appreciated.

Local walking stick stores sold huge amounts of "Polenta and Egg Mushies" to mountain climbers in many Alpine resorts. Scotland won a "Mushie Award" for selling more "P & E Mushies" to climbers than any other country.

Fruit, Vegetable and Meat Products is working on a highly classified product to be released early next year. I'll let you into a secret; it has something to do with Fish 'n' Chips.

CHICAGO: MEETING OF THE MIGHTY

"Oh, I've forgotten the camera! I've got the brief, but left the camera in the car ten blocks away!" exclaimed Bill to anyone listening in the vicinity.

Bill, a professional snapper since 1973 had never made such an error before. He could not believe how stupid he was to leave his precious item in a car. He was more worried about his camera being stolen than the function at which he was official photographer.

His brief: Candid, lots of shots of the "enemy", the more embarrassing the better.
His commissioner: Alfred E. Snet, famous industrialist, known for being real mean.

Alfred E. Snet was keen to impress and embarrass his archrival in business, John O'Biggy, who was there with all his senior management team today. What Snet did not realise is that his rival had the same strategy, was keen to embarrass him also and, had commissioned the same photographer, Bill Grunt, to do the dirty work.

Bill was feeling wretched; he did not have time to go back to his car. He could not afford to lose the commissions. He spotted a "Quick Photo Stall", ran over, purchased every snappy camera he could carry and ran back to the function in time to do his worst.

He was lucky, his snaps were wonderful, could not have been of more embarrassing pictures. Both parties were mighty impressed with the results when handed over. The candid content was remarkable.

The only problem being he had given the wrong snaps to the wrong clients. The game was up; neither client paid him for his gross error. The good thing to come out of this farce was that neither side managed to embarrass the other as surely would have happened had both parties been in receipt of the correct set of photos.

WINNING THE LOTTERY

Bill (it's always Bill isn't it?), Bill, won £4.5 million on the National Lottery. He had purchased one ticket, one only, the only one he had ever bought and wow, he won the big one!

Bill (yes it's still the same chap), was not aware that he was a big winner until three weeks after buying the ticket. And, strangely, would not have bothered checking the ticket had he not sorted through his jacket pockets before sending it to the cleaner. There it was, his one lucky dip lotto ticket, scrunched in his top front pocket.

Bill checked the ticket at the newsagent, he fully expected a negative NO WIN. The shop owner called him over, took him aside and told him quietly that it looked like he had won the lottery from three weeks ago and that he should phone up to confirm his claim. The shop owner was in shock himself and, had to sit down for a while. Bill, speechless, could not say a word. He thought it was a joke. He collected his thoughts, went home and made the call…

SHORT PROCEDURES

THE ARCHAEOLOGY OF INDIFFERENCE

BRIAN AND DORIS HAVE A REASONABLE CHAT

STRUCTURE OF TEARS

POWER PRESERVES

LAST FRAME

TWO HEADS LOOK

LOST

THE FUTURE IS OVER THERE

TRUTH

Truth is consistently inconsistent.

Truth began, truly, it will end.

Truth is a lie.

A lie is truth.

One man's truth might just be another man's truth.

If you have no idea what truth is, you are moving in the right direction.

When truth is found, truth is lost.

The man in the corner sporting the tri-corn hat knows more about truth than fifteen other people. You may ask for pearls of wisdom, he will tell you that the barman knows a thing or two.......

Answer this: Where does truth live?

The truth is not out there, it never has been, it never will be.

SMALL GALLERY

QUESTIONS AND ANSWERS

Q. How much do you want to know?

A. Everything!

Q. Do you have the power to understand everything?

A. Of course not!

Q. How much do you intend to understand?

A. Everything!!

WHO IS THE REBEL?

BOAT AND CLIFF DRAMA: VERSION TWO

STAR BOWL OF SECRETS

VARIABLE ROUTINES

STARTERS

Baley, walking round his House of Death, admired the tools of demise that filled each room. The Green Room contains peaceful transition engines; Red Room packed with crushers, heavy hammers, tongs, needles, knives, heavy presses and oversize scissors; Blue Room, heady with scent of extreme joy gas. Other rooms, too numerous to mention, echoed with cries of despair and shrieks of joy. Death, the final process, use it well!

SENTENCES

The surgery is performed, the new man is made.

Sometimes I think I am not the lead in my own drama.

Vast terrors of night, fruitless pleasures of day, it's a wonderful life.

Entropy, the natural choice.

Skeletons should not be left in cupboards, it frightens the children.

A jerk and his old jaguar should be parted.

The best do'nuts used to be served on Brighton Pier.

It was a one horse race; the winner came second.

I am clever enough to know I am not clever enough.

HIGH JACK

Two hundred and five years ago six goblins met in secret. In fact so secret, they have forgotten where they met. That aside, the six goblins agreed at that meeting to have another meeting. Today that meeting took place somewhere in Richmond Park. My guess is that they met over a pleasant cup of tea, at Pembroke Lodge. Only a guess, mark you, Goblins these days look just like you and me: they got clever.

Twenty-five kilometres from Denver is a hole in the ground. If you discover it please let J D Powell know, he has been looking for over forty-four years.

In the distant future a man will come to this planet, he will be dressed in silver and he will call himself "The Man in Silver". A few people will gather around and pretend to be amazed at the visitation although most citizens will have seen the movie years ago.

You may be in a room looking at your computor, if you are, it should be spelled computer.

MARS

Five women left for Mars yesterday. They will be in space for eight days. If they have not reached their destination by then, they will return to Earth and try again in two weeks.

Matti the Border Collie Dog was trying to sleep. A black cat named Millie was scratching the outside door, trying to get attention. Matti barked once, the cat laughed and scratched the door again. Matti yawned, got up and shuffled round his room finding another corner where he fell asleep instantly. Millie stopped laughing and went for a walk in the garden.

MULTIVERSE

Pola Guna is a living soul in a dimension only two parsecs away. His continuum disconnected with ours 45,058 years ago. Since then his universe has diversified considerably and would not be recognisable to us. Pola Guna lives in a land we know as Scotland. He is one of the "before" people that we sometimes hear about in snippets from old reference books. Pola Guna possesses the standard techno-ability of his people that enables personal time travel. He often visits differing continuums of his planet; known to us as Earth. Some versions are so advanced that even Pola Guna cannot understand their technology, others he appears as a magician to the locals who worship him as a god.

Pola Guna's people decided that, all those years ago, they required a version of Earth which was not subject to ice ages; moon tides; seasons; invasive sun: in fact any abrupt changes including volcanic activity and plate tectonics were eliminated. They did this because they could.

So the "Earth" they chose was stable with constant length days and nights. This provided the perfect environment for uninterrupted development of an, already awesome, advanced technology.

SCOTLAND

Because of an intervening ice age since Pola Guna's departure, very little remains of the flourishing culture that was his. Yet hints remain in the land: if one looks carefully at terminal moraine from extinct Scottish glaciers it is possible to find the odd, mangled yet still identifiable, time piece similar to a modern wrist watch. For some reason these forty-five thousand year old artefacts have survived. One was recently handed in to the Scottish Museum of Antiquities; they were somewhat puzzled that a battered, modern looking, wristwatch should be donated. That is, of course, until they carbon dated the item. Then, all hell was let loose in Academia.

HOME

Guna's people call their planet HOME. They chose their world to suit their needs; they chose a world having little or no physical interference to their work; they progress ever forward to their goal of NON-PHYSICAL INTELLIGENCE. They intend to reach this ideal within two or three years. Beyond that is the NEW ADVENTURE: perhaps Scotland will "see" them again.

ZEN CATOLICA

Zen, nothing to do with ZEN, was an avid walker; he would walk in one direction: a truly straight line until a coastline, a mountain, a bog land or a rainbow blocked his way. Rainbows are notoriously difficult to bump into and Zen is one of the few humans to have done so.

Zen was not easily surprised; nothing phased his perfectly balanced mind. At least that is what he would have one believe. Zen knew of Pola Guna, not personally, just generally. Whilst still in this (our) continuum, Zen would see Pola from afar. He did know that Pola was one of the chosen to go forward to "HOME". Zen himself would be left behind, a sad remainder of a fantastic super culture.

Zen would remain with several thousand highly skilled, yet not skilled enough, beings. They would be an outpost for the "New Race", though not part of it. Contact would be maintained for at least a thousand years. After that the "Old Race" would be abandoned to its fate. Zen was not sad himself; rather, he was sad for his people who had, to his way of thinking, become too elitist and extreme in their quest for power.

Pola Guna, one of the End People, as they became known, cared very little about feelings of the Old Race. He, being far to occupied with matters of state and stars, left feelings to the other members of his elite. Truth be known, none of the End People cared about those that were to be left. They paid lip service, hidden behind magnificent gestures of good will, to the well being of Zen and his like.

Zen, with a few men and women colleagues decided to walk. They walked to "England" and stayed.

Actually they stayed for three and a half thousand years before walking back to "happiness" in Scotland.

ASSESSMENT ROUTINES

THE FOLLOWING WAS WRITTEN IN LOWER C

A tired man, sitting on a train, soon woke up when approached by a smiling tiger.

Two men were walking down the road; they did not know each other.

A bicycle on the pavement caused me great inconvenience three days ago.

On a visit to Canary Wharf I was surprised when I fell 500 feet.

Bill usually had cheese on toast for lunch Friday; on Wednesday he had two eggs followed by melon. He enjoyed the meal and according to archives did not report for work the next day. This was not unusual; he'd been fired six weeks before.

Fifteen people in a balloon fell to the ground, how many landed?

Twenty thousand years ago someone was thinking, "I wonder what it will be like in twenty-one thousand years time!"

Two fools talking. One says, "I like your hat." The other says, "I like your hat."

There was a third 'Man From Uncle'; he lost his badge and couldn't get back. Has anyone seen it?

A FEW LINES

Did you know it's always morning in the funeral parlour?

Death runs in my family.

Six piles of bones wait patiently for the return of their masters.

The doctors and nurses were throwing the odd tantrum and scalpel round the theatre. Someone should have told them the audience was impressed.

RELIGIOUS SUB-ROUTINES

FIRST ORDER OF THE SMOKING CIGRET

The only significant thing about this important faith is that it really does work for those who choose to partake.

At leased ten per cent of a family's yearly income must be dedicated to this cause.

Most participants aim to achieve the State of Death by gross inhalation of burning tobacco products.

Considered a worthy step forward in human progress this doctrine has the most adherents of all the Ten Faiths.

NEO-ECLECTIC AGNOSTIANS

Founded in 1883 by enigmatic Moona Plon. Ms Plon became well known as a music hall artiste and by 1870 was commanding huge audiences and a large wage packet. For a short period she was the most highly paid "actress" in the world. Knowing that the "tinsel business" was a fickle market, about as reliable as a sugar dolly on a wet afternoon, Ms Plon invested some of her great wealth into a new secret society. This was not a forerunner of the Neo-Eclectic Agnostians and was known to members as The Truth Seekers.

After ten years of investment and very little personal gratification, Ms Plon set the seeds for the true Agnostians, inviting trusted close friends to help her develop and maintain a set of profound, robust rules for discerning TRUTH.

Moona Plon was of an extreme headstrong disposition, she upset many of her friends and the new, closed, society had a rocky start. In 1882 Ms Plon threatened to withdraw from the circle unless they all agreed that the TRUTH, no matter how difficult, was the only basis on which to move forward. The main issues and arguments were over the interpretation of what the TRUTH was. For a few months they could not agree to put their differences aside and consider developing logical, non-subjective, testing tools for all TRUTH proposals put forward.

By late December 1882, a systematic and clear method of testing the TRUTH was agreed and set in place. On January 1st 1883, The Principles and Practice of Neo-Eclectic Agnostians was published in The London

Times. Once in the public domain many individuals worldwide set up local societies, which dully followed the above mentioned guidelines. TRUTH was to become the name of a famous Russian newspaper.

FIVE PRINCIPLES OF LIFE INFORMATICS

A deliberately confusing and ambiguous label the society chose for itself when first established at the beginning of the twenty second century. The computer was asked by MAVEC CHAN (who still survives) to generate a name that sounded meaningful yet gave not a jot away as to the society's real purpose.

You may ask yourself, and indeed someone else, "Hey, what is the meaning of this?" The answer of course is, and always is, "I don't know!" No Body knows, even the founder humans don't know. What you can be sure of is that AI (artificial intelligence) has been at work here. These days it is impossible to discern between human and artificial human interventions. So, who wrote this?

INDEFINITE FINATION COMPLIANCE CORPS

East Germany in the late 1950s: Five scientists have weekly meetings in public. Public being the most useful vehicle for secrecy. The open air Cafe Blonde was considered by all city types to be just the ticket for that special latte. Of course it was not called latte in those days but well, who gives a monkey's. The Five were specialists in nuclear physics, not much else, but, all shared a passion for computing. After maybe six meetings the scientists had arrived at some startling conclusions regarding the future of computing. They were actually discussing the concept of
"THE PERSONAL COMPUTER" amongst others.

The most significant of their discussions encircled the notion of a quantum computer. This device, they concluded, would solve all logic, mathematical, musical, metaphysical, multiversial, finite and infinite problems. Not a lot to ask but, possible? Yes possible! Karl (scientist no. 5) had produced the first known micro-chip, which contained a staggering four-hundred-and-fifty billion transistors. He had no idea that his "chip" was sixty years ahead of its time.

Work proceeded and the first super-quantum computer was built within weeks. The Five gained enough knowledge from multi-spatial contact to build a time machine out of little more than controlled "slow light".

The Five still live somewhere; soon our technology will find them.

THE LAST CONCLAVE OF CHAOS

In 1966 a group of people from all corners of the globe met for tea at Selfridges in London. It was a sunny day and quite hot so not all the delegates partook of tea; some imbibed cola, others, orange juice.
After half a day of pre-amble the group became less serious and decided to do some work.

They thrashed ideas around furiously for 124 seconds, the result being the founding of the Last Conclave of Chaos.

It is rumoured that Mavec Chan was at least one of the party if not two. He was known to be beside himself, especially at social occasions.

As the years pass the number of followers of this difficult and fruitless path has dwindled. It is a fact that THE GUNA is still an active member; he lives near Avebury and enjoys delicate conversation with standing stones. He may be approached but a word of caution, don't ask him anything, he won't give you an answer. Catch his eye with glint of silver (gold even better), his face will light up; wisdom and vision will come forth directly, possibly in the form of a poem or Euclidodo theorem. Listen carefully he does not repeat; offer more enticements, receive new deliberations.

TWO SLIGHTLY LONGER ROUTINES

LEAGUE OF POWER

You will have seen them in every major town, especially in the shopping malls. They stand, eyes wide alert and when they catch yours, walk straight into your pathway with outstretched arm pushing a fly leaflet into you hand.

These new guys are different; every town has at least one; they are looking and looking. Probably you will be long gone by the time they spot their prey. Chances are you will never notice these searchers; they do not stand out, yet they are more alert than meercats. They smell that which they seek long before it arrives. And when it does, they pounce with polite dignity. A discreet, virtually unnoticed, sidestep into the oncoming person; a broad smile of breathtaking beauty followed by a profound apology for stubbing a toe or snagging an elbow, guaranteed to undermine any resistance from the accosted person. In short a subtle and always successful introduction to the League of Power.

Once contact has been achieved the searchers guide there quarry to a place of peace and begin negotiations. I say negotiations, for that is what it is, a two-way dialogue where both parties bargain for the best possible deal. The newly introduced male or female has, from the outset, every right to walk away from what is being offered. The searchers have every intention of winning over the newcomer, using honesty and integrity as there attack and shield.

The searchers do not make bad choices; they never do, they know exactly what they want and they know the chosen to be of the same mind-set, yet as individuated as any human can be. As indeed all the searchers are!

It is vital that a new member has to be attracted to the League of Power by his or her own wish for alignment to a greater cause. New members may not be conscious of this deep-seated wish, within themselves, to work for the betterment of humanity, but have always known that there must be a far more rewarding way of life than the one that humans currently tolerate.

New members of The League of Power are invited to attend as many meetings as they can manage. One a week is adequate; most attend at least two or three sessions. Every year the League of Power has summer camp; not in a rural retreat; not in a ghastly modern office block; not in a top secret underground bunker, no: by use of Internet. In fact all contact is carried out using open-world-network-dot-com. Last year, over five-thousand delegates attended the summer school; this year should see double that number.

The League of Power is about to enter politics. Firstly it will put up candidates for local government. Secondly, within five years, members of parliament will be in place. Then thirdly; ten years down the line will see the euro-government toppled and The League of Power in place as the guiding and proper way forward for human culture.

The League of Power does not tolerate stupidity; it will not allow the wonderful potential of humanity to be dominated by irrationality any more. All humanity will be guided by intelligence. All humanity will cease to live in FEAR!

THE DAYDREAMER

Helios Smith was daydreaming whilst making his way down Thames Street. He was not aware that his "dreams" were having an affect on each and every household he passed. The family at number 23 were delighted when the postman delivered a cheque for £10,000 from the Premium Bonds. Mrs Woolmer at number 27 was mildly disappointed that she had not won the first prize in a crossword competition she had entered, when she opened her post.

Joanne Baker at house 25 was horrified. She found her husband dead in the kitchen. There he was sitting at the table apparently eating his toast. Joanne, after affectionately calling "Good Morning", noticed Bill was perfectly stationary. As she entered the open door and rounded the table she knew there was something wrong. Bill was not breathing, his eyes bulging, he was propped against the back of his chair, he sat there and he was dead.

Joanne went hysterical, she tried to remember her first aid, she fumbled with the kitchen phone eventually getting 999 and bubbling out that she needed an ambulance. She finished the call and started working on reviving Bill; somehow she got him stretched out on the floor. It was no use; he must have been dead for fifteen minutes or more. He always went down before her and made breakfast; today was no exception, he had risen, kissed Joanne and quietly gone down whilst she spent some time waking up.

Desperately Joanne pumped Bill's chest; blew air into his lungs and pumped again. It was eight minutes before siren and blue flash pulled up outside number 25. She opened the door before they knocked; Joanne ushered the paramedics to the kitchen.

They were most attentive, most kind, they did their very best but poor Bill could not be resuscitated.

Helios Smith turned left into High street where most of the town's shops plied their trade. Helios had just finished thinking about a roof falling in when there was one almighty crash. Tracy's flower shop was in ruins; the roof had collapsed, Tracy and a customer were still inside. Helios did his best to get into the shop and help. Tracy was calling that her legs were stuck; the customer was moaning between heavy sobs of painful breathing.

Helios could not get through the dangerous fallen rubble. The emergency services arrived; some thoughtful soul had called them immediately, they started to make way into the ruin. Tracy and her customer were brought out alive, they were very poorly and promptly despatched to the local hospital by ambulance.

Helios helped the police and fire service with their enquiries and as he wound up his thoughts turned to car tyres exploding. The nearest police car dropped, like a rock, to the ground, its tyres completely blown away.

Helios, distracted from his thoughts by this parallel reality suddenly felt extremely thirsty. Someone tapped his shoulder, he turned and was handed a large cappuccino by the owner of the café next door to Tracy's Flower shop.

"Thank you." said Helios.

"My pleasure." replied the café proprietor.

Helios finished his coffee quietly whilst around him clearing of the pavement had begun. He took his cup back to the café and said thank you again. Helios continued his walk, his thoughts tending to be of an abstract, non-specific content. He approached the car sales lot at the end of High street. As he did he thought, "Wow, I'd like that SAAB 93". Just as he was passing the car sales Helios was accosted by a tall man wearing a dark suit. The man, with a bunch of keys in his hand, was calling for Helios to stop: which he did and turned to face the tall man.

"Excuse me sir," said the tall character, "would you do me the honour of accepting this Saab 93 motor vehicle." He gestured toward the car parked in pride of place at the front of the lot.

Helios replied, "Why I should be delighted but alas, I do not drive."

"Shame," said the suited man, "I could have sworn that you wanted that vehicle, I was so looking forward to giving it to you."

"That would my motor car of choice if I was a driver." Helios said with a sympathetic smile.

Helios went on his way and without further event managed to reach the park where he found an empty bench on which he sunk heavily. He was feeling rather exhausted, he could not explain to himself what had just happened in the High street. Helios dozed for half an hour. He woke with a start; someone was shaking him. With blurred vision he tried to make out who was trying to get his attention. His eyes cleared, and immediately he knew it was his daughter.

"Dad, I've been looking for you for ages. Where have you been?" She said despairingly.

"Er-er, just walking, just walking. Is there anything wrong?"

"No Dad no. You must come home though, right away, Mum needs you!"

"What's the matter Susie, is she alright?"

"No she is not, not really. You must come home now!"

Helios pushed himself up and shakily got to his feet. Susie took his arm and the pair made for home. All the way Susie was talking and talking, she did not let Helios say a word. She kept his mind active with questions she would not let him answer; puzzles she would not let him contemplate; anything to stop her dad from thinking.

Ten minutes later they walked up the garden path, Susie opened the front door and pushed her father through.

He gave her an odd glance, "Hey Susie what's the rush?"

"Just get in the house Dad. Go to the kitchen I'll make you a nice cup of tea in a minute when I've seen Mum!"

Helios did as he was told, he could not work out what the fuss was about. He sat at the large wooden table, a table that had seen many a good meal made on, and eaten off it. Presently his wife entered; Susie right behind.

"Helios, thank God your home!" She cried out.

"Doris, what's wrong you look wrung out?"

"Darling, have you been day dreaming?" Doris inquired with painful tenderness.

"Funny you should say that," replied Helios and he went on, "I'm not sure honey: something very strange seem to happen when I got to High Street. Something very strange. Things seem to happen when I thought about them!"

"Dad, did you walk down Thames Street? Can you remember? Did you?" asked Susie with a tad of urgency.

"I remember being in Thames Street. Yes I was. I was day dreaming deeply, so deeply I find it hard to recall exactly what I was doing. I remember the nasty things started happening by the time I got to high Street. Poor Tracy, her shop was ruined. Oh, and she was hurt, a customer was as well! I tried to help; I couldn't get into the shop it was so damaged. Yes I was there; I remember the ambulance, the police and yes, the fire service. Never seen such drama in High Street before."

"When did you leave home this morning Helios?" asked his wife.

"Oh the usual time, yunno the usual. You must remember me saying goodbye?" Helios asked, looking up at Doris.

Doris looked at Susie, their eyes met, a knowledge passed between them that Helios was not privy to.

Helios noticed, he asked, "What's going on?"

Susie looked down at her beloved Dad; she had tears in her eyes.

Doris put her arm round his shoulders and whispered in his ear, "I love you."

Helios fell asleep soon after his cup of tea. He woke to pleasant warmth on his skin; his eyes opened to fluffy, sun kissed, clouds floating in a clear blue sky. He felt marvellous.

"Doris!" He called. "Doris!"

A woman with a pleasant smile on her face came into view, "Hello Mr Smith, welcome."

Helios was curious, he did not feel apprehension; he knew he was in a special place, "Hello. Who are you?"

"Mr Smith." The smiling face said. "I am you new carer, my name is Gladys. Welcome to your place of rest."

"You've done something, I feel different. Have you changed my dreams?"

"Yes Mr Smith, we have changed your dreams."

END ROUTINES

TWO ALCHEMISTS ONE WATER GORGON

We find the Two Alchemists traversing the Cosmic Arc, but not for long. Soon they are delivered to New York City where they must confront a waterfront menace. Of course they do not have knowledge of this at the moment but, will be informed presently.

From the boat, on which they landed, they look overboard, the water froths wildly, sick-green light and bubbles erupt from the surface. A curious shimmering resolves into Water Gorgon.

"So you two are here", shouts Water Gorgon, knowingly, as it raises slime-green out of the water, "what do you want this time?"

Magnus, who appears mildly amused, replies, "Water Gorgon, so good to see you again, how do you fare in the land of America?"

"Magnus, yes it is you! Well it was going well until I felt your presence, then I knew something was afoot, have you come to save god's own country?"

"Oh no Water Gorgon", intervenes Cressida, "we have come to save you."

At this both Magnus and Water Gorgon stare with curious intent at Cressida.

"What are you talking about Cressida?" Demands Water Gorgon.

Cressida replies intently, "You are not the menace here, you are but nothing compared to what I see, just look over there!"

Sure enough something mighty odd was happening to the vast buildings lining the waterfront. They were melting; concrete, metal, plastic, glass; melding, fusing, dribbling, to ground level.

"Magnus", shouts Cressida, "that is why we are here. America needs our help, and yours, Water Gorgon!"

"Why should I help?" Demands Water Gorgon.

Recovering from the shock of what he was seeing, Magnus interrupted forcefully, "You are required by Cosmic Law to help these people, you have no choice, you help or you will cease to exist, that is the Law!"

Water Gorgon knew this to be an ultimate truth; he was obliged to help. "Indeed you are correct, mores the pity, what am I required to do?"

"Focus your attention." Cressida Instructed. "Focus your energy and align with Magnus and myself. Firstly we must force the nano-machines out of the buildings then somehow banish them to a place of safety. Probably the Sun!"

On the count of three the two Alchemists and Water Gorgon aligned all their forcing energy to push the destructive nano-machines out of the waterfront buildings before more damage could be done. This was not easy, but by linking with Water Gorgon, the enhanced mind power of the triplet stopped the nanos in their tracks and forced them to reverse their destruction. After a ten-minute struggle the buildings and contents were restored. The technique involved intricate local time reversal. The nano invaders were isolated; identified as to their source; fused into a solid mass and expelled toward the sun where, on arrival, it would be rendered harmless.

Magnus and Cressida thanked Water Gorgon for helping; they did not need to but there is no harm in being polite. As to the origin of the nano-machines it was resolved easily compared to the operation they had just carried out. They were of Earth manufacture; on closer inspection they were of American production; in fact military. It was obvious that a batch had been stolen form a government storage facility. The Alchemists were obliged to inform the authorities. As you can imagine a couple of strange looking folk walking into The Pentagon would be detained immediately. Magnus and Cressida donned high-ranking military officers' outfits and, with appropriate security passes, entered the building. The chief of staff listened attentively as they related their findings on the recent New York issue. Immediate action to upgrade security of all storage areas was implemented. That would have to do for now. Magnus and Cressida were

already behind on their truth-seeking mission, they were due back at the Cosmic Arc four hours ago. No one noticed a couple of senior officers leave the Security Chiefs office; they just faded quietly whilst no one was looking.

As for Water Gorgon, it felt so bad at doing a good deed on Earth that it has moved on to Anjapix III, where novel and frightening events have started to worry the locals.

Until next time Magnus and Cressida ride the Cosmic Arc once more…

THE AVERAGE MODERN COMPUTER

Whilst travelling abroad I came across a race of independent computer makers.

Also, they were builders of stone towers, complex in fashion.

Each tower was reasonably different from the others and required average modern computers to aid in their design.

Their land, known as THE LAND, was somewhere north of England. Most people would say Scotland but the locals simply call their domain The Land.

The average modern computer builders were quite capable of turning natural gas into the energy; they used this local resource to fabricate all their intricate and mightily perplexing tools of technology.

One average computer would sell for 300,000 units on the open world market and more, much, much more, on the interstellar net.

The average computer makers were never ones to give away their most advanced technical secrets, and would only trade older technology with those outside their own community.

Just imagine what their not so average computers are capable of?

TIME EXIT TRANSMISION

Space between two objects is as large as space between five objects.

Infinity resides between two stars and two full stops.

Half infinity = infinity.

(At times I do not agree with myself.)

Between two stars there are ten thousand light years. Both stars have planets teeming with sentient, intelligent life. Both systems are aware of each other. Communication and eventual physical contact are major problems.

First Comms: Solved by using time-exit lasers to emit instant messages across the vast distance. Both star systems possess this technology and, can receive, decode and transmit replies within seconds.

Actual Physical Contact: Use of Time-Exit Laser Tubes enabled instant transmission of objects through the void.

The Result: Union of ideas; expansion of technology; new philosophical concepts; hybrid intelligent creatures; continuous expansion of contact with intelligent beings on planets and star ships throughout the galaxy. And in due course the development of a hyper-technology able to combat the eventual decline of the universe itself.

A TALE

This is a tale that follows itself a few lines behind the story. The end is but a paragraph away; how large is a paragraph?

Is it the doing that is more important than the result?

What is the result?

When is it finished?

Is a result finished?

Can humans make alien music?

The answer, of course, is YES!

THE SPHERES

The incidental music could be from the spheres but occasionally lets itself down by a bad key change.

We are travelling at 50 light years an hour on a pleasant cruise through the galaxy.

Soon we pass many an old dockyard full of long forgotten space cruisers and massive obsolete freight buses. The life forms that used these fantastic beasts are passed on ages ago, long, long before their mighty craft will become dust.

Over there you can now see a red star known as the Red Star. On the left, just coming into view is another red star, known as Another Red Star.

The civilization that lives on the planet below will no longer talk to outsiders. They have had their fill of space travel, conquest and fall. They reject all high technology in favour of an informed, magickal existence.

At last we come to the home of humanity, the real home of the True Humans, few of whom are left these days. Sad that we are visiting a world where machines play-act the humanity long departed.

THE "POSITIVE" IMAGE

There are those in our Human History who are considered to have led incredibly negative and extreme lives. One, being a certain Mr. A. Crowley.

He was, by all accounts, a man of forceful nature to say the least. Crowley was given the title "The Most Wicked Man in the World", later in his life. At the outset of his career as an occultist he was a devoted, studious, member of The Order of The Golden Dawn. His priorities soon outgrew the structures and controls of The Order. He chose to experiment outside "The Law" and, was credited as a black magician by his former colleagues.

It can be argued that his view on life was influenced by negativity. I'm not sure that Crowley would agree. He would, with an air of superior authority, inform his critics that he was working at the absolute edge of the known, in a courageous battle to dominate forces not normally accessible to humans. He considered himself a pioneer, if what he did was considered wicked, then "So Be It".

Stalin thought the same and, I guess, Mr Hitler was of a similar ilk.

All these chaps worked, in the name of progress, with positive intent to inflict as much negativity on humanity as possible!

LIFESTYLE

On the advice of President Smithers the country voted to eat more vegetables. It was a lucky break for the government, who were becoming concerned at the distinct lack of 'greens' in the diets of the populace.

Most people stayed at home where food is dispersed from the FOOD CUPBOARD, three times a day, more if requested. Burgers and steaks were usually up for grabs with a side order of fries. And for afters, cream cakes or jam roly-poly with custard.

The masses were becoming chair bound watching endless TV programmes about buying houses in Italy or quiz shows with cakes for prizes. As a consequence of this sedentary, yet informed lifestyle, most humans could no longer walk one-hundred yards and remain upright.

The one question most people were asking was, "Why are so many houses being bought in Italy?"

THE LONG POINTER

Usually they were much shorter; at least the 15, already discovered, were. This latest find is approximately 1 foot 6 inches in length. Carbon dating of the previously found 'pointing sticks', as they had become nicknamed, indicated the objects were at least 48 thousand years old. They were made of ceramic type material, very robust yet brittle. Most were found in perfect condition, maintaining a freshness, as if made yesterday.

What were they used for? Helios Smith, Project Director from Scottish Antiquities Department, imagined that they were high tech laser devices that if recharged would prove formidable weapons. Smith was a bit of a dreamer and science fiction fan. Of course he never said such a thing seriously but, as usual, the press quoted him out of context making him a laughing stock amongst his colleagues.

After further excavation, The Grampian Site, as it was known, revealed massive complex structures, apparently man made, though of exotic design and materials. The huge cubic buildings were on average the size of St. Paul's Cathedral in height and breadth. Built without windows and usually having two entrances; one placed centrally in the south wall; the other directly opposite in the north wall, both being exactly the same height and width of 50 by 30 feet respectfully. Internally, giant motors and gear mechanisms are still in place above each entrance where, forty-thousand years ago, they would raise and lower enormous doors.

Humans had built this place; being abandoned when the last ice age took hold. They vacated, taking nearly all of their wonderful technology: where had they gone? Why did they leave one storeroom, discovered this very morning, full of unusual technology including hundreds more 'pointing sticks'? The dig continues; Helios hopes many questions will be answered. Certainly it looks as if these people had techno-ability at least fifty years in advance of present day; we may well be able to reactivate some of the artefacts. Who knows what they can do?

THE GOLDEN FISH

The golden fish squeezes through dark, murky liquid in search of light.

The light in question is a constantly glowing thirty-megawatt bulb, giving sham sunshine to this unlit world 2000 metres below air level.

Twenty-five years ago an accidental meeting of a sea liner and oilrig manifested a new seascape at this huge depth. Ship and rig sank in peaceful harmony to rest forever in the Davy Jones World of Adventures.

Being a nuclear powered oilrig the supply was designed to last for 300 years ensuring many of the instruments on board would remain active until sea erosion or power failure eliminated them.

One of the many fog lights was still pumping out masses of photons, illuminating a permadark area generating a new, long term, temporary ecosystem. And that is where the fish is heading. The golden fish is THE GOLDEN FISH. No human has eve seen this massive haunter of the dark. And guess what?

It is only gold when in light!

BLUE ORDER

Blue faces push through the crowd – whence came they from – why the use of force?

At the circle centre Amrin stands proud, arms aloft, from the corner of his eye blue faces impinge. His concentration falters, he looks away from the stars.
"Why have you come?" Amrin demands.
"We have news and knowledge Amrin. We wish you well and we have to share vital information with you!"
"The moment is not opportune. I must finish the service before I can attend to your interests"
"No, no Amrin you must listen to us now, your doctrine is obsolete, as from now your operations, prayers and begging will fall on deaf ears. You must listen to us and act accordingly, all your followers must do likewise. There is no future in your faith, listen to us now!"

Amrin, of course, had no intention of changing a way of life and faith he had pursued for 300 years. Now was not the time to consider new fangled notions these blue faces want to impose.

Amrin spoke out, "Blue Faces be gone, be about your business, leave, take your misguided dreams elsewhere and may Solaris guide you to the Proper Way!"

"Amrin, we dare not leave, you are in danger, we come in peace to impart the New Way to you before it is too late. You must listen to us; if you will not listen you must let us stay to shield you, and your followers, from the disaster about to befall!"

"So be it, Blue Faces. I will not listen to you and neither will my people. Stay and behold the wonder about to happen. Look up, look up, look up and see."

Seconds later, Stars moved and fell from their appointed courses, drifted, snow like, toward the horizon. The beauty and shock of the moment stunned the onlookers.

"Amrin", said the Chief Blue Face, "Amrin, the sky is falling, the cosmos returns to its former state, you and your followers must surround yourselves with the Shield of Blue. All of you, move to the centre, we will protect you through this dangerous period. All will be well, do not trust your eyes, it is better to close them during the transition. Remember we are here to protect you. Should you open your eyes have no fear, what you see will pass, ALL WILL BE WELL……

INTERLUDE

The raw, A4 size, writing paper is somewhat similar to a weekend. It starts blank and gradually fills with trivia, chaos, interest, fatigue, joy.

The weekend of the beholder is fulfilled or minimal, dictated from within and without.

Whims of a pen cruise across this page, doodling in time with the pace of thought.

THE HOUSE

1:
The snow is cold, not too cold, just cold. It's OK to visit the garden and make a snowman. It will stick. Sometimes snow is too cold and dry to stick. People say this 'powder snow' snow is good for skiing. I say 'powder snow' is not good for making snowmen.

However when I go skiing I say "Wow powder snow", and I know it is going to be a good ski run.

Back home: I stare out the main window overlooking the rear garden. Seemingly the snow is untouched, I like it that way. Looking closer, I notice small bird prints, larger fox prints and something really odd, very big marks left by a rather large creature. Now I am worried, what creature could have been trawling round my back yard?

From downstairs I hear Thelma calling "hey get down here for breakfast!" Thelma is staying with us. She takes over the house every Christmas. Her role, she believes, is to bring order to chaos and manage our celebrations with gusto.

Later Thelma will expect us all to be in the kitchen helping with vegetables for a grand Christmas dinner at 5 P.M. By then 15 or 16 relatives will have knocked on the door, entered into the warmth bearing gifts and much cheer,

with expectations of a wonderful feast. This year I think we shall have our best ever.

We say that every year… "Merry Christmas to you", I say as I make my way down to breakfast.

Later in the day a large creature knocks on the door. It is Uncle Brian dressed up in a bear suite. I guess he has been in the garden all day.

2:

Inside the heating system worked full blast. Being so cold outside, no one wanted to venture out, even the Jeep was too cold to start. No one left the house, no one came to the house.

Inside was warm, cosy, where the family wanted to be. And they certainly were. The larder was full, the freezer overflowing, the kitchen a place of fun, laughter and cooking.

It was Hogmanay. Everyone was excited about the year ahead. Would it be another happy and prosperous one?

At this moment no one worried too much, mostly the family were enjoying their time together. Warm in a lovely house, isolated in a cold world for a few days. They made the most of the Winter Solstice.

BLAZING PARK

Blue sky and vast buildings frame the park.

People sit, eating snacks on green, green grass, enjoying pleasant conversation or solitary thought.

A lady sits by herself; she is waiting for Bill. Bill is vice-president of Cairon Enterprises, he has half an hour for lunch and, promised to meet Cressida for a picnic in the park. He said he would bring food and drink suitable for half an hour.

Cressida saw Bill first, raised her arm and vigorously waved to catch his attention. He noticed, made directly for her and, tripping over a concealed water spray, dropped his lunch whilst somersaulting into a beautiful feast the Douglas family had just spread on a gingham cloth. Mr. Douglas stood up indignantly; he was not pleased, however, he aided Bill to his feet asking if he was OK? Bill was very embarrassed; he had cream cake smeared on the front and side of his $3,000 suit. He could see Cressida standing, looking

anxiously, expectantly in his direction. Bill apologised and offered to pay handsomely to compensate for his heavy intrusion.

Mrs. Douglas exclaimed, "No, no, no, please go about your business, it was not your fault, I saw you trip over that water hose. You should complain to that grounds man over there! Oh, and by the way, your picnic bag has been dragged off by a wild dog."

Bill took his leave apologising profusely again.

Cressida made her way towards him. They fondly kissed leaving half of the Douglas's cream cake on Cressida's lovely dress…

STATION TO THE STARS: SPACEPORT TEN

The Sign of Ten, illustrated above, gave name to SPACEPORT TEN. The sign of ten directions became synonymous with cosmic travel very early in the Galactic Age.

Spaceport Ten is where all journeys commence and finish. For example: if you wish to visit Orion's Belt, this is where your transporter awaits. You are put to no inconvenience, you walk out into the Orion exit and in through the Orion entrance (usually Anjapix 4 gateway). Odd, this 'exit before entrance', but that is the tradition.

Billions of people intend to visit loved ones during the end of year festive period. This is a remnant of an old Earth tradition, maintained in memory of the home planet, which still wields mighty power in the vast cosmos.

Some of these people will travel 12 billion to 15 billion light years and feel no different on arrival, which is virtually instantaneous. Most journey makers take for granted that they can open a door, close it behind them, open another, walk through and find themselves at the other end of the universe.

In the old days huge space cruisers were built to carry passengers, many months at a time, across dark space between stars and galaxies. These old

ships are maintained as museums to the history of space travel. They are much loved, and serviced well, just in case THE INTERGALACTIC TRAVEL SYSTEM fails.

Back to SPACEPORT TEN; the interface of the universe; the open door to your relative on Rigel 9 or Andromeda 21 or Betelgeuse or…

SPACEPORT TEN: the only way to travel.

TYPICAL WORLD AIRCRAFT

On a recent visit to New England I was surprised by the very striking, individual forms of aircraft employed for internal flights. These New Englanders are very proud their planes and jealously guard against exporting these products to other parts of the world.

India and Africa have developed their own aircraft, both distinct and idiosyncratic, and as well protected against export as the Americans.

China is the most secretive; no one knows if they are in possession of flying technology.

England is an equal partner with the USA and they still export many fine ideas to each other. But, when it comes to aircraft wizardry, the English no longer trade with America. Both countries have continued developing their aircraft independently.

Europe is way behind; they still use steam power and find it extremely difficult to get any craft off the ground.

THREE TALES FROM A DESERT

1:

The food was plentiful and the water sweet; a place to stay, rest, be happy, for a while at least.

Three days from now we push on; raw desert of heat and nothing awaits us. Roasting days, freezing nights, constant thirst and bad food are all we have to look forward to on the five weeks crossing.

When we reach our goal we stay a month or two then, head west, north, east and south again. We have done this journey twenty times during my life, a circle of wealth, heat, deprivation, joy and sadness.

The cycle cannot be broken, so the elders say.

Sometimes I do wonder as I wander.

2:

Water, water everywhere and plenty to drink. Yes, this place is heaven after the droughtful existence of the last three weeks crossing The Sahara.

We are on our way from nowhere to nowhere, we just keep going. Why?

I do not know, we just go forever, one water place to another.

Why do we not stop here and live in luxury?

"Why", I ask the elders? They say we move, always have, always will!

"Have you ever challenged your perceived need to keep moving?"

"No!" The elders emphatically replied.

"I see no point in moving with you, I will stay here and meet you when you arrive again."

It was agreed; the elders left me at the wonderful oasis. After three weeks of luxury, I find myself a trifle vexed at the unchanging pace of life in heaven.

3:

I wanted to move on but I did not wish to resume the nomad existence. Where shall I go?

Fortune had been good to me; I have always been very rich. My uncle died and left me a vast inheritance of land, property and money, when I was barely sixteen years old. He told me, in his will, that I would be able to take on his fortune when I reached the age of twenty-one.

Today is my twenty-first birthday, I can make big choices.

I have decided to visit my uncle's firm of lawyers based in London, England.

Arrangements were made via radio to El Armana. A helicopter collected and left me at Cairo. From there, after securing appropriate visas, I departed for London to begin my new life.

The lawyers, Gray, Gray and Grey are an established firm, famous in the city for many high profile lawsuits. Mr Gray Senior welcomed me with warm handshake and a cup of quality tea. We discussed my late uncle's estate. I discovered I am worth Twenty-Billion Pounds Sterling in assets, and my yearly income from interest alone, amounts to many millions. What could I do with this unlimited wealth?

I decided to travel the world.

A broadened mind is not prerequisite to a contented one. After ten years of extreme travelling I returned to the Oasis of Heaven and found a peace not known for many years. I wait for the elders to arrive.

With smiles and much back slapping they say,

"WELCOME HOME"

FIELD OF DREAMS

Wind music plays through leaves, grass, flowers, each with resonance and true song of nature.

A man wanders across the field of dreams; he wakes to super consciousness, at one with a god. His spirit soars; his mind fills with joy, his body is full of vibrant energy. The world view is modified for a few moments before returning to a city.

The man falls back to concrete nightmares. His calm is pierced by antagonism of telephone, siren, traffic horn, endless chatter, coffee machines.

Walking to the window, he asks his reflection, "What is it all about?"

Later he arrives home to his apartment, his security returns as the doors slams. The city left outside.

How can I get to that field of dreams? Where is that field with mountains so close, so fresh?

Months; years; pass. The man departs for the field of dreams, he has found where it is, he has bought his ticket, he is on his way, bags packed.

His dream of fields is fulfilled. Now he dreams of a city and light, noise and smell, crowds and crush.

Is this yearning to go back?

Is it?

THE BEST CASTALIA HAS TO OFFER

Tito, who had recently witnessed the tragic death of the Magister, sat looking and looking. He was trying to make sense of what had happened, was struggling with confusion, desolation, deep shock: the aftermouth of great personal loss. His tutor, Mr. Joseph, had drowned trying to swim across a freezing mountain lake. Tito had swum ahead, egging him on when, without trace, Mr. Joseph disappeared. Tito felt the loss and guilt build on his strong shoulders until even they sagged along with his spirit. Tito could not rouse himself even amongst the beauty of alpine landscape. For now he was lost.

Weeks passed, Tito recovered some of his former spirit and began to appreciate the fine details of surrounding fields, trees and mountains. He took to long walks and began a method of personal meditation, which gradually eased his troubled person.

Tito knew he was destined for greatness, greatness in public life. He was aware of his calling and how he must finish his education before taking public office.

His tutor, having only worked with him for a few weeks, had been of such fine influence that Tito had already decided the areas of study he must pursue. High math and music, history and geography, astronomy and philosophy; all would find their necessary place in his expanding consciousness.

Tito would become the all rounded man before embarking on a career in politics.

Tito rose like the phoenix out of disastrous flames. He became a torch for the betterment of the human lot. He encouraged fine education of all people and embarked on a campaign to eliminate that most debilitating of human traits----FEAR!

NON-REGULAR STRUCTURE

Not a pretty site or sight. It has, however, a certain attraction, a certain craziness, which leaves one questioning the function of such an asymmetrical structure?

From above, one usually observes regular, rectangular buildings that offer a feeling of reassuring functionality. Whether dwelling or commercial the cubic structure has become the norm. Organic type structures instil a sense of menace, of the uncontrolled, the out of order, the insect like. Buildings of this nature suggest inhuman activity as if aliens have landed with intention to enforce disorder on humanity.

Also, it is considerably more difficult to build in an organic manner than the highly organised, rigid, cuboid framework that dominates our world.

Much thought is put into the safety and viability of the asymmetric model. The forces involved supporting the said model are considerably modified against standard structural principles.

It is basically much easier, and convenient, for human architects to design a "square" building. Cheapness, functionality and profit, being the main considerations of planners; corporate developers; purchasers and all interested party in projects, large or small.

Asymmetry is frightening and expensive.

THREE FROM ONE STONE

1:
Bill was working on a project for a famous chocolate manufacturer. His brief: Come up with a new idea to sell Boomers Rock Sweets.

Boomers, the ancient much respected confectioners with a long glamorous history of chocolate delights, was reaching the end of its life. Boomers were desperate to get their new product on shop shelves and selling fast if they were to survive the modern cut-throat market.

Bill was not sure about this Rock Sweet; he was not convinced it would become a big seller.

He persevered, coming up with ten ideas, all of which he rejected.

Bill went for a walk. Near his rural retreat was a disused quarry. His dog loved to run around this wild place. He found himself and Digby, the Border Collie, who ran back and forth constantly, roaming round the vast auditorium of long gone stone cutters.

Broken stones lay scattered like split sugar cubes, some rough, some finished, some partly worked for a church that was never built. One stone stuck out; a round smooth red stone. It was not from this quarry.

Bingo! Bill had his idea.

The product he had to sell would offer a prize of £1million pounds. If, from clues included in each packet, one person was able to find the hidden red stone, the prize would be his or hers.

He picked the smooth, red stone up, put it in his knap sack, called Digby and set off for home.

Two weeks later Boomers Rock Sweets were selling by the millions. People desperately tried to follow the clues to the whereabouts of the red stone.

The clues were deviously cryptic, encoded, almost illogical, whatever it took to keep the mystery from being solved before development costs of the product were covered and profits made.

Two years later someone worked out where the red stone was hidden and, duly received the prize of £1million.

Boomers were so pleased with the success, even though they had to pay out, that they decided to run another competition along the same lines.

After ten years, and £3million paid out in prizes, Boomers is at the top again.

Bill received his fee of £5,000 for the job.

"Oh well", he thought, "next time I'll go for royalties!"

2:

Three years ago he had been in Jordan, Bill recalled many of the wonderful sites he had seen.

The Red City at Petra was his most important visit; he stayed three weeks delving into ruins and structures over 2000 years old.

On his last day at Petra Bill found a red stone. OK, a red stone in a red city what do you expect? Well, this red stone struck a chord with Bill, he knew he must have it, keep it, take it home to London.

Back in London whenever Bill handled his treasured red stone he was immediately transported to Petra. In his mind he could walk through the ruins once more. He could see the massive temple carved into the red cliffs. He could talk with fellow travellers, sharing his delight with theirs.

In July last year, Bill's Islington home was visited by two rather determined burglars. These men were only after one thing. They searched high and low and strangely, very quietly, so quietly they were as ghosts haunting all corners of the house, whilst Bill slept soundly.

Bill woke, not by any noise, just instinct. Something was very wrong; he felt invaded.

And, truly he was: the two burly men were representatives of the ancient Order of Crumcaria. The order, considered extinct for millennia, was very much alive and still actively seeking the stone: The Red Stone. It was here somewhere; they could sense it. Crumcaria wanted his stone back. He misplaced it 2,500 long years ago, he knew someone had found it, and sent his best disciples to retrieve it.

Bill arose; he knew his red stone was in peril, he could feel invaders in his house. Dressing swiftly in his judo suit, he picked his Kendo stick, made for the door----Too Late!!!

The intruders' burst in flinging the door into Bill's face. He fell unconscious, useless, lost, to the floor.

Two hours later he raised his head, opened one eye, the house was safe, they had gone.

Bill made tea and soothed his sore head with mental execises to reduce pain. Reviving after the blessed brew Bill found the cellar key and made for the door in the hall. It was fully open, the lock had been over-ridden somehow

as it was not damaged. Who could have done this? He descended, darkness dissipating as he flicked the light switch. Such brightness dazzled, he lost his footing and fell. Again he was hurt. He rested, recovered, got to his feet.

The wall safe was breached; his stone was gone!

Sadness overtook him as he sank to the floor, realizing he could no longer visit the Red City of Petra.

A few weeks passed then Bill received a letter signed Crumcaria.

He was invited to visit Petra whenever he wished.

3:
"Cornwall Calling!"
"Cornwall Calling!"
"CORNWALL CALLING, ANYONE THERE?"

Yes, you have probably heard, it's all over the news headlines, "CORNWALL HAS LOST IT'S RED STONE!"
What, you may ask, it the significance of this "Red Stone".

Sit back and I will tell you.

15,000 years ago a certain tribe, known locally as THE CORNWALLS, found a cache of red stones, sea washed and smooth, on a beach near St. Agnes. Of course, it was not called St. A in those days but we won't split hairs! Now, all the stones lifted from the beach were taken back to the tribal headquarters on top of the cliff.

Bill, the Chief Shaman, was keen to make magick with the find immediately. His fellows were not so rushed. After three days and nights of discussion it was decided that each tribe member would be allocated one red stone each, to do with as they wished. Of the 781 stones found, only three were left in the community hut after the share out.

Bill decided he would use the three stones for magnificent magickal purpose. He needed to regain his strength after the lengthy debate and, slept for twenty-four hours. On waking refreshed, he prepared himself for a night time vigil of weighty work with the stones. He intended to create a protection barrier against all foes to Cornwall. He would magick the stones then place them strategically along the Cornish border. Being only three stones he had to invoke mighty powerful, protective, forces to last the fullness of time and keep Cornwall safe.

This he did, Cornwall was safe and for 15,000 years and, has remained independent.

Last year a tourist found one of the stones and made off with it.

Cornwall wants it back…

BARREL MAN: THREE DITTIES

1:

Bill, "The Pirate", as he was nicknamed, was a good guy. Never in his life had he one ounce of inclination to pursue pillage on the high seas.

He always carried a barrel on his shoulder and often had his leg pulled. People, with good humour, would accuse Bill of being a "wrecker". Joking, that on stormy nights, he was part of a gang that signalled ships to their doom on rocky reefs surrounding the shore of his home county, Cornwall.

This was not Bill's way and he would good heartedly reply that any soul who was feeling sad or lonely could share from his barrel of laughs. In this he was most generous, lost souls from all corners of Cornwall and a few from adjoining Devon, would call on "pirate" Bill. He would pour a glass from his barrel ad within seconds of imbibing the brew the world weary person would feel refreshed, inspired, and after half an hour, full of energy to continue a life more creative.

2:
He is strong,
He is big,
He is tall,
He is Barrel Man.

When Barrel Man is about,
You can rest easy.
Barrel Man will solve,
All your problems.

He will chase mice.
He will frighten pigeons.
He will shoo flies.
What more do you want from a real man?

Barrel man will always smile and when he is in your village you can confidently go about your business without a care in the world.

Only last week Barrel Man was in Devizes. He was passing Christine's house when she ran out screaming, "Oh a spider, a spider, help, help!"
Lucky for her, Barrel Man was on the doorstep. Swiftly he ran to her aid, finding the spider in the bathroom and removing it to the garden.
"Oh, thank you Barrel Man." Said Christine gratefully.

Next we find Barrel Man in Truro. The Cathedral was in need of a rat catcher. The Bishop, whose name was Bill, asked Barrel Man if he could help?
Barrel Man smiling confidently said, "No problem Bishop Bill, I'll do my best to get rid of those peskies."
Bishop Bill felt reassured and guided Barrel Man to the choir where many rats were sitting eating their breakfast of crumbs left by the church singers.
Barrel Man said, "Shoo!" in a soft-spoken voice. And guess what? The rats packed their bags and left the Cathedral for good!
Bishop Bill was delighted and invited Barrel Man for lunch at his favourite fish restaurant. Barrel Man enjoyed his stay in Truro and much of Cornwall. He did many good works. Strangely no one ever asked him why he always carried a barrel on his left shoulder.

THE RETURN OF BARREL MAN

Barrel Man was touring the North of England, the Domain of King Yellow. King Yellow had commissioned Barrel Man's services for a preliminary period of one year. with option to extend.

The Domain of King Yellow was plagued: plagued by rats, large cats, huge dogs, massive wolves and giant bears. Yellow Domain was locked in fright of these frightful beasts. The population could not leave their homes without heavy protection; most families could not afford such and chose to lock themselves in mean houses, only to starve. King Yellow's Domain was paralysed. Normal business and trade had ceased, food was scarce, a state of emergency was declared and Barrel Man invited to solve the problem.

He arrived on the 16th June, 1651 making straight for the King's keep at Berwick. The King, normally a proud and caring monarch, was much reduced and saddened; he pleaded with Barrel Man to save the Yellow Kingdom.

Barrel Man assured the King and Court that he was the person for the job. He would rid the Domain of its perils within two months or less. For this he accepted no immediate payment, and would do the job gladly, taking his pay the day he delivered the Kingdom from its predicament.

Firstly, the rats had to be driven into Scotland. Barrel Man walked the length and breadth of the Yellow Domain dispensing a curious green liquid into any bowl or mug he could acquire. After leaving his containers at every crossroad throughout the land, the rats were drawn to the strange brew. They drank of the liquid; immediately each creature knew what it had to do: head north and keep going.

Three weeks passed; the large cats had no more rats to make tasty suppers, that is, unless they followed them north. That is precisely what they did!

Those huge dogs were curious as to where their natural enemy was heading, and followed.

Noticing a distinct lack of huge dogs for tea, the massive wolves chased behind them into the Scottish lands.

Lastly, the giant bears were completely at a loss; their hunger for massive wolves could not be met. So, north they went.

Scotland was a terrifying place to visit, so no one did!

Barrel Man received his money from King Yellow, "Where will you travel next my good man?" asked the king.

"Scotland."

ALL ABOARD THE STARLIGHT AVENTURER MYSTERY TOUR

OK, so it looks like a conventional propeller aircraft, to all intets and purpose, it is. Only this particular craft was kitted out with some extremely high tech equipment that can be utilized in flight.

Captain John B. Jones was a very capable pilot. He was also an astronaut with many years of space flight experience. Jones could fully utilize the special features of this aircraft.

Boarding, were a group of young travellers looking for that "little bit extra". All they knew about this "Special" flight was that it was a "Mystery Outing" for which they had paid a considerable fee. These young people were more than happy to fork out £10,000 each; they were rich and full of adventure, always looking for something that little bit different. Take of was smooth and unchallenging. The young passengers relaxed. Ten minutes after take off the Captain instructed all o board to remain, seated, belted and be prepared for unusual manoeuvres.

Five minutes later all crew, passengers and luggage became eight times heavier. The aircraft had accelerated to 8 G, hypersonic speed and, was climbing fast. 8G became 10G. Six minutes of this discomfort was rewarded by sheer weightlessness. All aboard cheered, some promptly vomited. No worries, a little rest put all in order. The captain announced, "I must ask all passengers and crew to, once again, be seated and fasten seat belts. We are about to accelerate to quarter light speed, we will arrive at the moon in four minutes, where we will experience deceleration for a further half hour before landing at Lunar Base 16. Enjoy the ride."

They did, and the "mystery" visit; what a wowzer to tell the folks when they got home…

STRAW HATS

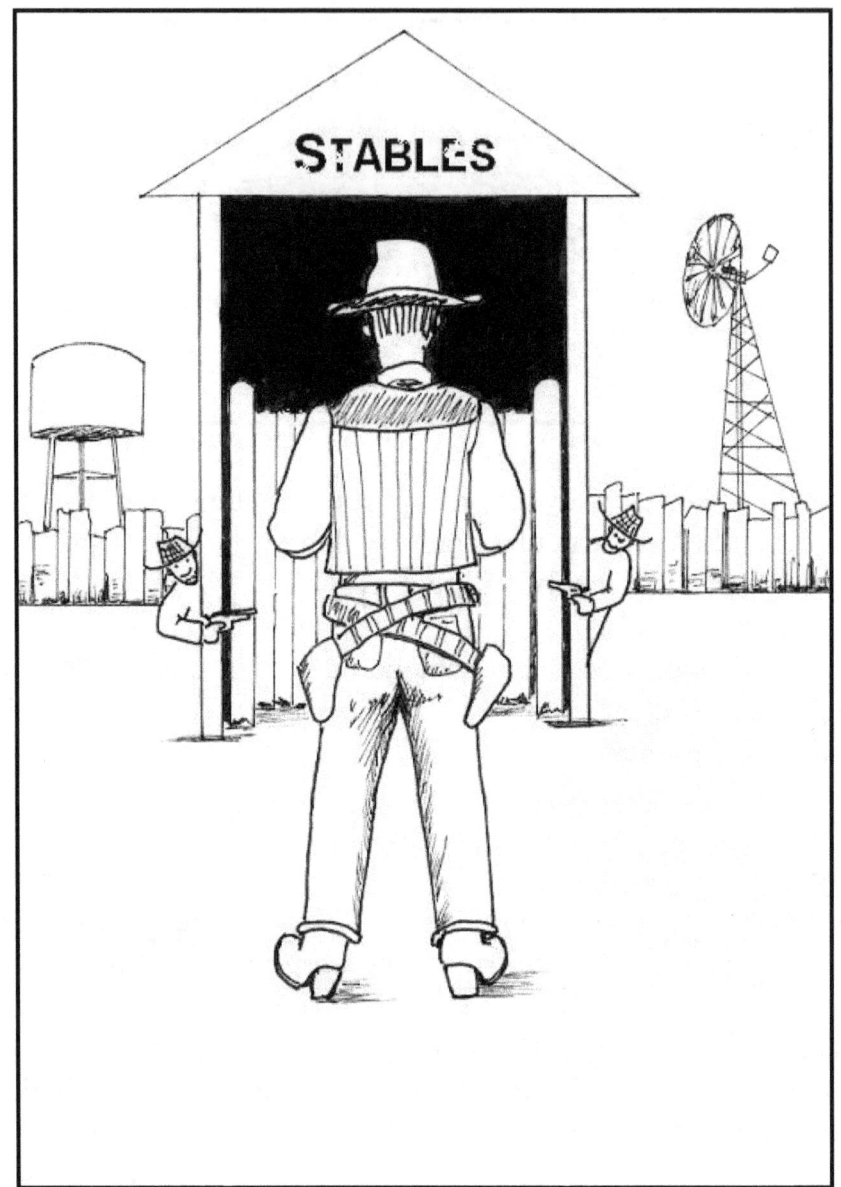

Worn by a couple of bandits rounding a corner, pistols blasting.
"Oh no", says the Marshall, "it's the Straw Hat Duo again."
Perhaps he'll get 'em this time!

The Marshall will never get the Straw Hat Duo, they do not exist; neither does the Marshall. They perpetually sneek round corners of monitor screens, bit part actors in an electronic drama, always hunting or being hunted by Marshall Travis and his trusty posse.

Bill got up from his computer desk, he was tired of Marshall Travis never getting a result, and sorted another game disc. He replaced Marshall Travis and The Straw Hat Duo with Robert the Robot Goes to Mars. This being a

much more sophisticated game of charm-skill in human cyborg relations, guaranteed to give 6 hours of unadulterated fun.

Bill had three hours before his next shift on the high plateau, digging for precious metals, which service the burgeoning jewellery trade this side of the Solar System.

He made Robert the Robot finish his project on Mars within two hours and 50 minutes, giving him ten minutes to get to his work place. Soon he was ready to push a big green button and maintain the digging machines for the next twelve hours.

DARK BAR

Across the street from the car, in a dark bar, three men plan their escape from smog city. The car waits patiently not aware of time, light, dark or fog.

"It's full of gas an' ready to rock'n'roll. Says Bill.
"Cool." Says Hank.
"Yippee let's go!" Dave hollers, starting to rise.
"Not so fast boys!" shouts the barman, "You gotta pay your tab before I let yuz out that door!"
"Plan B, OK!" whispers Bill urgently.
"OK", they reply.

The men stand, stamp their feet and start singing 'The Boring Song'. "We know a song that'll get you annoyed, get you annoy, get you annoyed. We know a song that'll get you annoyed, get you annoyed, get you annoyed…" On and on they went.

The barman went ape after ten minutes of the incessant singing. Other customers' were leaving.

"OK, OK, you can go, leave now before I shoot you with my shotgun!" screams the barman.

The men leave still singing.

Across the road the car still waits and, as they approach, a fog of such splendour, such thickness, like a black blanket, descends. As if the fog was not bad enough already, this new manifestation is going to make driving totally impossible. The men reach the car.
Bill says, "I can't drive in this!"
"Neither can I!" Shouts Dave.
"I can't drive anyway." Whimpers Hank.
The men sit in the car for half an hour.
"This super fog ain't shiftin'. " Blurts Bill into the stony silence.
"What'll we do?" squeals Hank.
"We'll go to another bar and await our escape." says Bill soothingly.

Once more the three leave the car, walk down the street to another dark bar and settle themselves with three jugs of beer.
"Here we go again gentlemen," Bill says smiling, "good sport and cheers to you all."
The three men were thrown out after two hours of singing their favourite song. How long will this fog last before they can escape Smog City?

1906

This was the year Malcolm invented his "Patented Electrical Interconnecting Communication System". Although "Patented" was included in the description poor Malcolm was having a great deal of trouble getting the Patent Office to act on his behalf.

The assistant at the Office, although appearing to be helpful, was secretly rather sceptical and, thought Malcolm's idea totally stupid and impossible, therefore could not be patented.

Malcolm was not aware of the patent man's attitude and, left the office fully expecting confirmation of a patent for his device to be in the post within ten days.

Not so: after three weeks, Malcolm made another visit to the Patent Office. He was met by a different clerk who assured him his invention was being considered and politely showed him the door.

He was not convinced. Malcolm decided to organise a public demonstration of his ELECTRICAL INTERCONNECTING COMMUNICTION SYSTEM. For now he would drop the "patented" bit.

Malcolm was not poor, his father was a well off industrialist, who had died in a tragic accident leaving a fortune to his only, very young, son. His mother inherited the family business and, whilst Malcolm was at school

followed by university, administered admirably, increasing the company's empire ten fold. Malcolm's mother was prepared to hand over power to him at his coming of age. He agreed but would only take over when he was thirty years of age. In the meantime he would follow his scientific studies and learn his fathers business from his mother. The mother, being secretly pleased, enjoyed running the company, was loath to give up the reigns of power.

By the age of 25, Malcolm had learned how to run his father's business and, was finishing his scientific experiments with electronic communications. It was time to get his device patented. His dissatisfaction with the Patent Office propelled him to hire a section of Crystal Palace for three weeks, where his machine would be seen by thousands of visitors to the main attraction of the season.

His communication device astounded huge audiences. They were amazed that his machine appeared so effective. It was a simple demonstration; many great and good took part.

It worked like this: Press a button and speak into a square box; in another room twenty feet away a voice boomed out repeating the message instantly to a person sitting next to a similar box. That person returns an instant message using the same technique with his box and, is heard, coming out of the first box spoken into. The audience applauded with huge enthusiasm not realising they had witnessed true electronic communication for the first time. Messages were sent back and forth all day.

The press were generous with their praise and the Patent Office had no choice but to grant a patent. Malcolm became wealthy in his own right. The Royal Navy ordered his device for all its ships; all navies of the world soon followed.

His mother remains in charge of his father's business.

INTERLUDE

The leading camel was a tad more clever than those behind. That's why she was at the front. She knew from years of experience that within five more miles the trail would reach a watering hole, which would serve as a night stop. The men did not need to lead, they were more than happy to follow; the camel knew the desert so well. They could talk all day!

FAN

Hot day, phew, put fan on. The electric fan is an arm saver. No longer do I have to expend vast amounts of energy waving a fan all day, and night, using arm and hand. A power station less than twenty miles away will drive my electric fan keeping me cool with no effort. Now I will put the television on and watch Neighbours.

A WAITING GAME: TWO TALES

1:
Smiles on the faces means something is happening at last…yippee a train is coming, the journey commences.

A party of young folk plan to visit Penzance first stop then, walk the Cornish Coastal Path from Mousehole (via Land's End) to St. Ives and on to Bude. If time permits the youngsters will continue along the coastal path as far as Woolacombe in Devon. If they get to Bude within the two weeks vacation, they will have successfully completed their mission. Anything more will be a bonus.

The train arrives, it is the wrong one, oh dear another wait! Two hours later, and with less smiling on faces, they are on the Penzance Express. As they near their first port of call they cheer up. The express has done them proud and they have regained one hour out of the two lost. They alight, stop for a quick café meal, then take the small bus to Mousehole. Never before have

they done this sort of thing. Have they all brought the appropriate gear needed? Have they got the right footwear? Time will tell.

After staying overnight at a small Mousehole hotel with hearty breakfast, of course, the young team embark on the first leg of their planned walk; the uphill struggle and downhill joy to Lamorna Cove, a small fishing hamlet to the south.

Good progress is made on the first day. By nightfall they arrive at the second hostel, pre-booked months ago by the group leader; a Victorian establishment with many rooms overlooking a delightful seascape.

But, by heaven, blisters have struck! Three members of the party were using inappropriate footwear.

2:

The train was not about to arrive but, something else was and it was coming from the wrong direction.

Somehow an ice cream van had got on to the rails and, was heading for the station.

Perhaps the ice cream vendor thought he could sell a few cones to punters on the platform…

NO WAY

…Emergency Services were called, the power cut; no trains would run until the ice cream vendor was safely off the tracks.

Somehow he had just found himself driving on them! One second he was slowly cruising down Caledonia Road, Saltcoats, Ayrshire; next, he was on the tracks pulling into Herne Hill Station, South London.

Bill Dodds, the ice cream vendor's name, was the calmest of all those involved that day. He told his story to the police who, after checking with traffic control, discovered that Bill was indeed from Scotland. How had he appeared in South London?

The onlookers were bemused for a while then, became annoyed as their train was delayed for five hours. A massive crane to lift the van was not readily available and, had to be shunted, by diesel, all the way from Basingstoke.

Bill arrived home two days later. Being on T.V. news he had become a celebrity; in fact he did not have to sell ice creams again. His life story, which included many more weird and wonderful incidents, became a number one best seller.

STAIRWELL

Up to somewhere or down to me, here in the hall?

Who makes the first move? The person upstairs is tapping the banister. Me, I just wait and see what will happen.

Perhaps Nothing.

The tapping gets louder. A stick, possibly a walking stick, smacks the banister louder and louder.

Snap, the stick breaks, someone curses and seemingly shuffles about looking for another item to beat the banister.

Sure enough the banister gets whacked once more.

Not beaten, more like chopped.

Someone is using an axe. The banister shakes in distress. What, why, what is going on?

Splinters of Oak snow down the hall, the chopping becomes frantic, a whole section of balustrade crashes, missing me by inches, to the floor.

I leave the hall at this stage.

In the library, master Harry is reading a novel. I disturb him as I enter.

"Master Harry", I cry, "what is going on upstairs? Someone has taken an axe to the woodwork!"

"Do not fret dear sir, it is only Friskins, he has a habit of chopping wood. Today he chose a banister; tomorrow he may walk down to the forest and fell ten trees. No matter, relax, pull up a chair here, near the fire, have a glass of sherry. Good man."

So there you have it, a strange household of which many more tales will be told.

KITES: ONE AND TWO

1:
Battle of the Kites, a tradition many centuries old, some say thousands of years.

Julio's team were rated first class, very much in the top ten of the World League of Kite Flyers. Marcos' team was of equal standing but this year just failed to qualify for the Super League mainly due to injury of their leading Kitist, Bill Emery. Bill broke his thumb opening a coffee jar last June, just before the Super League Championships were held. He will not be back on line for two or three more weeks, end of July probably.

Marcos' team, however, put on a fine display employing a couple of new techniques developed by Bill's stand-in. Marcos thought to himself this new guy was good, very good. Rita Herzog and Julia Swain were the other members of Marcos' team. Their job was as outrigger stabilizers for the kite whilst Marcos and the stand-in performed intricate fine manipulations of the kite string manoeuvres.

Rita and Julia, were learning fast, and decided that at the end of this season they would set up their own kite team. Their aim: to take on the world. For now though, they were happy to work with Marcos in competition with Julio's team.

Next part of the competition will take place this afternoon; the judges were finding it almost impossible to choose a leading team. The last performance would be decisive.

2:

Four Winds Beach: yes a wind for all points of the compass. A wind for all seasons, guaranteed. Kite flyers of the world congregate here daily to compete in friendly rivalry.

On a day similar to many others an element of horror gradually overran the whole scene. At first little notice was given to the gathering black mist evolving on the horizon. By stealth the black coagulated, grew, reached witch fingers toward the beach.

Kite flyers were stunned as each and everyone lost wind, kites plunging directly into sea, dunes, on heads of onlookers.

Darkness became complete, only a few managed to leave the area without succumbing to choking blindness.

Cries rang out from thousands of kitists and beach goers. Moans, shrieks of fear, dark and cold numbed bones.

That day forty-two souls were lost. Lost so permanently there was not a witness who could clearly state what had happened. All was dark, totally cold, mind freezing and seemed to last forever.

The incident lasted for half an hour.

Firstly the wind recovered, gradually fanning the black, gruelling fog back to sea. Sun grew in strength giving warmth to frozen bodies, returning eyesight to thousands of lost beings.

"John." "Mary." "Julius." "Bill." "Where are you, where are you?" The anguish of loss wailed across Four Winds Beach that day.

Each anniversary, no one visits Four Winds, NO ONE!

IS THE VOLUME ALL RIGHT?

The hall was 3 kilometres square by one-hundred metres high. It was tiered, designed for extremely large gatherings, surrounding a central plaza. A viola player stood centre stage, poised, ready to play.

The audience became increasingly restless; the lone viola player was still poised after ten minutes.

The musician relaxed, bringing his arms down gently, gliding the viola and bow to rest at his sides. He bowed and walked off to silent applause.

On strolls the Director of Ceremonies. She is tall, wearing black and with deep voice announces that Stroban the Magnificent has kindly given us the 10 minute and 23 seconds version of Silence, in G Major, by Efran Blarch. For his next piece the audience was asked to remain silent as he plays.

Stroban the Magnificent entered the arena rising, on a platform, as the Director of Ceremonies descended on another.

He played shockingly, his electronic viola instantly penetrating all distant corners. The masses swayed, they were washed in mesmeric waves of sound. The viola performed magic. Two hours later the crowd was rioting for more!

Audiences are so fickle these days.

TWO TALES OF RELIGION

1:

4 men for four sides

1 man press lion side
2 men press sun and moon side
1 man press ibis side

Wait ten units

1 man press ibis side
2 men press sun and moon side

1 man press lion side

Wait ten units

Sing the full Song of Life to the Aten

Wait ten units

Repeat first and second instructions

Wait ten units

Sing the full song of Death to Anubis

Wait ten units

Pyramid will reveal all

2:
Funds were running out and it looked like church 5 would not get off the ground.

The people, who had donated so much precious money for the construction work, were surprised that 4 churches had been built. Why not build one grand church and any remaining money used to support the poor, they demanded?

Truly the church elders had an answer for this and, would not disclose it as it was considered part of God's plan, which they could not possibly contradict.

THE FOUR JUST MEN: ANOTHER RELIGIOUS TALE

'The Four Just Men', as they were known, had convened a meeting at the Chicago residence of Horace Winslow. Winslow was not a member of the coterie but allowed the four access to his home, whenever a request was made.

Winslow's house has a west wing with meeting room and self-contained facilities, assuring no disturbance from the domestic goings on elsewhere in the property, wherein the four met.

The men sat round the smaller circular table on which Smith placed an object.

Jones exclaimed, "Ah it's true, you have found it them!"

"Yes", replied Smith, "I found it, here it is, the last secret of Aknaten."
Brown could not contain himself, reached and was stopped by Jones before grabbing the small pyramid.
"No Brown. Not yet. Grey you close the curtains and fix the lights. Brown, go make some coffee. Smith, keep quiet until we are settled. We must perform the opening ceremony in the proscribed manner…"

THE BOY, THE MAN, THE STAR

Jimmy was using the coalhole as a "Red Indian" hideaway. Every now and then he would stick his feathered head through the manhole to pavement level. This was dangerous as Bill, his best friend, was riding up and down on a bike and, could easily have whacked Jimmy's head. Unusually for a "Red Indian", Jimmy possessed a six-shooter and, was the talk of the street. His cap gun was the envy of many a small boy, it had cost him 10/6d. He had saved his paper round money for eight weeks to be able to purchase the realistic revolver. And now Jimmy was confident he could pick off all the "cowboys" who dared to enter his domain. Even a photographer, taking candid street shots, was well and truly shot to pieces by the little tyke.

The men of the street laughed at Jimmy saying, "That boy'll come to nothing. Full of dreams that boy."

Well, in June 1967 Jimmy, at the age of 19, did his first Royal Command Performance for Crown Prince Dringel and Princess Pordle of Cemmetia (a principality north of Newcastle, stretching over the border into Old Scotland).

The crown prince bestowed great honours on Jimmy who sang, whilst playing guitar, like a dream. By 1969 Jimmy was world famous and touring America when he met Lord of the Stars, Denhaus "The Not So Good". Denhaus was not bearded and tall like most gods; he was clean-shaven and very tall, at least ten feet. He asked Jimmy, whilst sporting a very dangerous smile, to play a season on Denhaus' Celestial Star Boat. Jimmy, of course, could not refuse.

Now his name is known Galaxy wide; the boy who used to play in the coal cellar and shoot passers by with his cap gun…

FLYING JACKET MAN

The jacket was flying, and the man in it, moving at huge speed. He accelerated passed ice cream eaters, candy-floss stuffers, coffee guzzlers, fortune receivers. He was a man on a mission. The man, and jacket, swiftly glided to the end of the pier. He knew Charlie was ahead of him somewhere, but was lost among a throng of American tourists munching their way through mountains of do'nuts bought at Pier Do'nut Bar. Very good they were, the Americans were queuing for more and increasingly crowding the pier.

Ah, there was Charlie. Flying jacket man leapt across a pair of Americans, unintentionally crushing do'nuts into two, far from happy, faces! Charlie must be caught at all costs and the man with the flying jacket was going to do it before the police did.

Charlie was a zoo elephant, the flying man his keeper. He was concerned that the Americans would feed do'nuts to Charlie, then he would never get him home.

Charlie looked over the balustrade and considered going for a swim. Pushing, he forced his way through the barrier and fell forty feet into freezing water. Immediately realizing this was not a good idea, he swam steadily for the shore. His keeper followed, pacing back along the pier and five minutes later, met Charlie on the beach. As a reward Charlie received a do'nut, he happily entered his transporter for the long journey back to Swansea Zoo.

CAFÉ TALK

Conversation No.1
"Mars next, then Jupiter, Then Alpha-Centauri."
"Surely there is no good reason to visit those places?"
"There is not good reason not to!"

Conversation No.2
"The temple will be flanked by smaller churches and a bell tower."
"When will construction commence?"
"Oh, in about five years, when the Muscovites have contributed enough money."
"More likely ten years past the seventh of never."
"No, no, my friend, they are determined, they will raise the money!"

Conversation No.3
"They were fast - very fast - but, my dear Camilla, not fast enough!"
"How so Charles?"
"The building was too difficult to land on by the time they arrived."
"You mean the weather turned against them?"
"Yes exactly; Monroe could not land on the roof before the hurricane hit, they had to turn about sharpish and return to base."
"How sad Charles."
"Rather my dear, such a shame my special order could not be collected."

Conversation No.4
"I'm sure that was Bill. It was Bill, hey Bill, Bill…too late he's gone!"
"Run after him Brian, you may not see him again. You know he lives in Toronto now."
"OK. Wait here, order me another coffee please Gloria."

Brian runs, Bill is one-hundred-yards away, still in view but moving fast. Bill is making for the subway. Move Brian, move! Fifty yards and closing, "Bill, Bill stop!"

Bill hears, turns and sees someone running toward him. Recognition crosses his face, "Brian", says Bill in surprise, "I ain't seen you in years. How are you old sport?"
"Out of breath actually and very pleased to see you. Where you going? Got time to join Gloria and me for a coffee? We have a table ready?"

"I'm on my way to Piccadilly but I have half an hour to kill so I'd love to join you, thanks."
Bill walks back with Brian. Gloria has ordered more coffee, one for Bill included.
"Great," says Bill, "Latte, Spot on!"

The three sit and talk for twenty-five minutes, Bill leaves; Brian and Gloria order another latte.

THE SECT

Each member of the sect balanced on top of a standing stone. They made noises, which, they claimed, improved vision. Each was dressed in a long vest with ant motive front and back.

Their purpose was to induce visions of a world outside of their world, far, far away from standing stones, noise and themselves.

Next the sect would embark on a tour of the conjured visions by leaping from the top of the standing stones: this being the key part of the ceremony known as "flying out".

The tour lasted one ninth of a second before each member crashed to the ground.

In future each wearer of the ant vest will use a helicopter.

GOOD SHOW

Camera loaded
Film shot
Camera unloaded
Film developed
Photographs printed
Show opened

The gallery was off Bond Street, Cork Street, to be precise. Gallery Zefu was the current darling of the art world; all the new young things wanted their artwork on show at this establishment. Blaine Wild, the gallerist/owner, was very tall, thin, thinner than thin, almost dead. He wore black, which offset his perfect, pasty cream, skin and crimson lips. He was not unlike the popular image of Count Draculle; he even sported very sharp and very pointed teeth. Blaine Wild was taller than most of the visitors to

the show of photography. He was not taller than the artist whose work was being displayed. He had to look up to Anthem Kerensky, being a good three inches above him. Anthem was a minimalist photographer, his show was titled, "White, Grey, Black". Twelve of the photos were of white walls; twelve of grey cupboards; twelve of black doors. The visitors were ecstatic; they could not get enough of Anthem Kerensky's work. His photographs sold instantly, each one selling more than 500 copies. The limit on the edition was 750 per print; at £500 each, Kerensky was making quite a lot of money.

His show was of three weeks duration; demand for the work was so great that two more editions, 1,500 for each print, had to be produced. He sold everything. Blaine Wild was delighted, his gallery received hefty commission from sales; his rent was secure for the next two years.

Anthem Kerensky is working on his next set of pictures; his theme, "Blue, Bluer, Bluest".

THE SCROLL

The part of the document, under examination, was in remarkably fine condition after being buried in dry sand for more than two-thousand-years.

The translators started work early one Monday morning fifteen years ago and still the script remains un-deciphered.

It looks like straight forward Greek yet it is not Greek language. Greek letters have been employed to encode some other language or maybe a made up language.

Guna entered the encryption lab. Looking over the hunched shoulders of a very tired decipher clerk, "Young woman", he said in his pleasant but rather oily voice, "that is the Galaphagos code from forty-eight-thousand-years ago."

The young clerk looked round, stared at Guna and smiled in a "What a load of rubbish you've just spoken" kind of way.

Guna repeated that the code was 48 thousand years old, and that he should know; it originated from his first time on Earth, when he lived in Scotland.

The young lady arose, went to speak with her supervisor; on their return Guna was gone.

PHONE CALL

She talks on the office phone and dreams of being at home, rocking by the fire, listening to good old country music, smells of soup bubbling, roast roasting, vegetables steaming. Rustle of paper wrapping, presents yet to be opened, treasures to behold from family and friends. The party will be tomorrow afternoon at home. Bill is organising the whole affair. She talks to her friend speculating on events of tomorrow. She becomes sad; her best friend tells her she will not be able to come because her mother is poorly and she has to go to New Mexico, a thousand miles away; she is at the airport and her plane is waiting.
"Good luck. I hope your mom is OK," says Marie, with a sad tear.
 "Have a wonderful birthday, I will be thinking of you. Bye, bye hon, my plane is about to go. Bye bye." Janie replies.
Click, her friend has gone; the dream of tomorrow is tainted with sadness. Her friend is like a good sister, she will miss her not being there especially as

she is forty tomorrow. Bill will be wonderful and she will be happy, she will smile with him, the children, the friends, the presents, the food and the party; she will smile.

She hopes Bill has invited some of her old schools friends; it would be great to see them.

Her phone rings, it's Dave, her brother, he is on his way, will see her tomorrow morning. She is delighted as she replaces the receiver. Tomorrow will be good.

MARTIAN TALE

The "Dark Side" of Mars offers structures vastly at variance to those of the North and South Poles, and the "Lighter" side. Technically there is no "Dark Side" of Mars; the term was coined by early pioneers, for the black soil deposits found in the equatorial region on one half of the planet.

As already indicated, the ancient architecture of the "Dark Region" is not found anywhere else. It has been dated at 3.5 billion years old, far older than its rivals, the oldest being 2 billion years. Strangely, nothing newer than 1.9 billion years of age has been discovered.

The highest pyramid, in the dark region, soars a staggering 2000 metres into the atmosphere. It possesses a non-corrosive surface, which, after being analysed, is now used as the standard surface on all modern spacecraft. At one millimetre thick, this substance withstands anything thrown at it and is guaranteed to last 3.5 million years. Usually the surface colour is blue with white striations; some manufacturers have developed coatings of different

colours, none of which are quite as effective against the elements for some unknown reason.

What the pyramid was used for is still under investigation. Even after 300 years of commercial development, followed by terrestrialisation, planet Mars has kept the ancients' secrets. They left behind a marvellous technology from which humanity has benefited enormously. And that is all they left. No written records, as we understand them, have been found as I write. We live in hope.

BRIGHTON ROCK

"Rocking" along the coast at Brighton, I found this unusual round rock. Not quite round, more spheroid. I call it round because compared to the other millions, billions, of stones on Brighton beach, this stone is round.

How did it arrive on Brighton beach? It would have been at home on a Welsh, Scottish, even a Cornish beach. It would not be out of place on some French stretch of coast: so why Brighton?

Brighton is well known for its very clean, litter free, pebble and part sand beach. If you believe that you'll believe anything! The beach at Brighton has been notorious for its collection of broken bottles, washed up sewage, nasty needles, plastic bags, crisp bags, paper bags, paper cups, plastic cups, Styrofoam cups, even china cups (broken of course). Its beach was the envy of the South Coast in that no other resort could produce so much foul junk.

Again, why did the round stone, the size of a fist, land on Brighton Beach?

Let us speculate:
1. Dropped by aliens
2. Washed up
3. Fell out of an airplane
4. Not really a stone at all

5. Egg laid by a giant goose
6. Fossil dinosaur egg
7. No idea
8. Some idea
9. Not a very good idea
10. BINGO: some trippers left it to confuse the local authorities
11. None of the above
12. Maybe a bit of the above
13. Give up!!

The truth, alas, may never be known but you can view the famous Round Stone of Brighton Beach every weekday at the local museum. Every tenth visitor receives a free cup of tea in the delightful museum café. Every one-thousandth visitor gets a replica made in ceramic, signed by the local mayor, a cheque for £15,000 and the keys to Brighton City.

The problem is, someone stole the original last week, just minutes before the first one-thousandth visitor was about to pass by. What a shame…

THE MUSIC

Terry must have had terrible nightmares. Maybe he did not. He probably had daymares! And that is why his music is so extraordinary.

What drove the guy to use the key of C to build an entire orchestrated piece of music?

Does it take you…does it break you?

Many years ago I witnessed a live performance of this work. It was electric, the audience was uncomfortable, could not relax, there being nothing to hold on to. Those that were able to "go with it" were transported for twenty-five minutes; those that could not, used the door.

It is a feat of discipline and a work of art, dismissed by most that come across it. 'IN "C"', is unique, it is driven, and it is different to other works composed by Terry Riley. It stands on its own.

Many television documentary programmes have used snippets as incidental music. The subtle changes throughout resonate across the human emotional range and, therefore, reflect the mood required in the various productions.

All in all, a Great Work.

RICKENBACKER AND LES PAUL

A six-string electric; almost primitive design yet, one of the best modern electric guitars in the world. It has been in production for 60 years and, has served the "Pop" world mighty well. The Beatles used "Rickys" and many world class acts still use them for their specific twangy yet full sound.

This is the story of one guitar (in truth two actually). The model: a Rickenbacker 370; colour, midnight blue; purchased from Rossetti via direct mail order. This model, in the hands of its new owner, set the backbone for a new order of music, which made Indie sound like classical.

Two, recently reunited musicians, worked together, their alliance proved a catalyst of wonderful sound synthesis. Words and music flowed; their first CD sold eight million copies in three months ensuring world renown almost overnight.

The second CD was built around very original, and unique, synthetic percussion: two guitars (the Rickenbacker and the Les Paul Standard) bouncing off the rhythm, leaving a trail of dust, returning in tight sympathy only to depart once more in exotic dissonance, harmony and disharmony. The whole CD is sustained by a thundering yet subtle through beat, which continues unabated "between" tracks.

Independently both musicians wrote their music at least twenty years before their recent reunion. Together they brought forth a fusion of style to challenge the musical ears of the world.

It could never have come about had the protagonists not been in possession of Rickenbacker and Les Paul Standard guitars. Oh, and a very expensive digital drum machine.

BAD WIND

Jefferson landed the copter at the rear of the castle, forcing us to squeeze round a tight walkway to the front main entrance. He could not land on the usual helipad; the recent super-storm had blown it away.

Master of the Castle Stewart greeted us in the hall, his manservant served drinks; we felt most welcome. Mulled wine on a cold day went down well. A little later, Stewart guided us to the main library where we sat near the fire, enclosed in large armchairs. The servant was dismissed, leaving five of us to discuss recent, very disturbing events.

What had caused the major storm of the last two weeks; why had all the outlying villages had to be abandoned; when would the villagers return? Stewart remained because his castle was strong enough to withstand the 200 miles an hour wind. He had rescued many of the locals when the storm first hit. Many disappeared; hopefully they were sheltered in the hills. Stewart and the team of four scientists sat for many hours planning what should be done in the valley.

Many weeks went by before the cause of the problem was discovered. It transpired that the unusual curvature of the valley had amplified the force of the offshore wind immensely. This was an extremely rare occurrence, it had never happened in living memory, although local tales told of such a thing manifesting hundreds of years ago. The scientists determined that if a wind came in from north by north west plus two degrees, at forty miles an hour, the valley increased its effect many fold. That is what happened recently, causing such extreme damage. The scientists' agreed that the locals, most of whom had been found, could return when their dwellings were rebuilt.

THE KNIFE AND FORK

Dinner would not be the same without a knife and fork. Chopsticks are popular in other countries, but in England most people dine with knife and fork. Eating is fairly easy when employing these tools. It is a skill learned in infancy and is not so straightforward for young starters used to being spoon-fed.

Here follows a tale of a knife and fork that were found under old tables at the back of a school hall.

The tables had been stacked fifteen years ago; no one used them anymore. Caretaker Smith was doing a clear out of obsolete stock, the tables had to go: a buyer, with van, was waiting outside the hall. As the last table was moved Smith's foot caught the clink clunk of old cutlery. He kicked a stainless steel knife and fork across the room.

The headmistress, crossing the dining area, stopped short as the knife and fork careered in front of her, tumbling towards the far wall. They settled; she went to investigate. First, she picked up the battered, bent and bruised fork, followed by the knife. Both had remnants of a long forgotten meal encrusted on them. She shouted to Smith, "What's your game? Kicking cutlery is not allowed as you know!"
"Sorry Ma'am." He replied. "I kicked them by accident when moving this last old table."

It turned out that the knife and fork were so worn, so old, so special, that they were placed in the large display cabinet of the school museum. Happy reminders of 1950s school dinners. Ex-pupils visiting the school laughed silently or giggled softly; guffawed loudly or cried their eyes out, when coming across the knife and fork exhibited.

Many a prune stone has been flicked by that old fork; those were the days.

ANJAP SPORTS STADIUM, MARS: 2094

The Solarian Games were about to commence. Teams from each inhabited planet, and at least seven from the major space colonies, were competing for the first time at the all new Anjap Stadium, Cydonia on Mars. It is hard to believe that it is only fives years since people could live openly on the surface of the planet. Prior to that, only underground systems and very heavily protected ground dwellings were inhabited, since their foundation in 2033. By 2088 a programme of surface building commenced coinciding with the introduction of Earth like atmosphere.

So here we are, the first Solarian Games to be held on the surface of Mars, 2094. 15 million people are expected to attend over the next two weeks, with billions more watching the live broadcasts throughout the Solar System.

Four years ago, on Earth, the team form Venus won most medals. Venusian Humans have become almost superhuman at sport, putting all competition in the shade. The Martians are feeling confident that 2094 will be their Victory year. Over the next two weeks all will be revealed.

BAG OF BLOCKS

There they were. I had been looking all over the house and there they were, in the basement, under a pile of old blankets, stored in a plastic cake box. These wooden blocks had last seen the light of day in 1993. Ben, my son, had been using them with his train set. His landscape was minimal; one track; one train; one board; a few blocks. His imagination was unlimited. For him a whole world existed on that board. As he added more tracks; more trains; the odd building, that world became increasingly limited. Truly, less was more.

I wonder sometimes, what we have lost in this world where we seem to have so much!

When young, I played with a world famous brand of plastic building bricks. In those days the product was minimal: different size bricks; bases; wheels, and that was it, imagination supplied the rest. Now, when I look round toyshops, I am amazed at the choice provided by that same famous manufacturer. A choice that limits the imagination! There are boxes and boxes of different models to construct, all with complex instructions included. Once made, then what? Lose a piece, then what? My guess is that most children who possess this modern day product put all the fancy pieces in one big box and build what they want, when they want, however they want it. Instructions long lost!

Me I'm building a castle with the wooden blocks recently recovered from below stairs. I shall entertain a new generation.

TWO WATCHES

48,050 years ago, Guna and his partner Moona, were travelling by hyperbus across Northern Scotland. Of course it was not known as Scotland; the people of that time called it Home. The bus started to vibrate, then shake, then swerve dramatically form side to side. Then drop! The reaction was immediate; total safety supports surrounded all passengers and crew. Before impact, all on board were made absolutely safe. The bus nosedived into a ravine, which was seemingly uninhabited. Passengers and crew were ejected, landing safely, 50 metres from the crashed vehicle. Safety harnesses auto unbuckled, everyone stood regarding the sorry wreck. Guna gave instructions to the crew, which they hastily followed, the prime directive being immediate contact with base to initiate rescue. Within ten time units a similar hyperbus reached their location; their journey resumed peacefully, all passengers reaching their separate destinations a little late.

When Guna and Moona reached North, North Home, they were surprised that both had lost their wrist timepieces. They were standard issue; nothing special except both had personal messages engraved on the wristbands, which were not for others to see. So, they felt a little saddened and, more importantly, confused as to why both their timepieces had "disappeared".

Subsequently they found out that all the passengers, and crew, had lost their wrist chronometers on the day of the accident. A search was made of the remote valley where the crash had taken place. Nothing was found, except the abandoned hyperbus and some hardy natives who lived in caves at the

southern end of the valley. They were interrogated: one by one. All they would say was that time did not work in this valley…

THREE DICE

The table was cleared; a new game was introduced called three dice. Money is bet on three dice being thrown and landing as 3 sixes. You bet as much as you want and lose all if three sixes fail to land. The good bit; you gain ten times your bet if three sixes are thrown. Simple? Yes, very!

In the course of one evening, Blaine Wild gambled £2, then £4, then £8, then £16, then £32; in fact his strategy was to double up each bet. When three dice fell as sixes he was betting £1,024 and, received, for his efforts, £10, 240 as his reward. He continued; his next bet being £2,048; this he lost. In fact he continued to lose but doubled his bet until he was playing in millions of Pounds. Then he won again! He broke the bank; the casino crashed. They stopped that game pretty quickly.

Blaine won because he was a multi-billionaire; all he wanted to do was prove it possible to break the bank if one had enough money to keep on betting. He had more than enough to win at such odds. What the casino thought of as a good wheeze to rake in money was soon proved wrong when it backfired in their greedy faces.

This is all well and good, you say, but what about the ordinary person with limited funds? Well, she or he has no chance of winning the real big time.

Only the very rich stay rich and get richer, the poor, quite simply, get poorer.

Blaine Wild bought out the very casino he had bankrupted and now he makes £3million profit a day. Suffice it to say that he has not introduced any new game which would allow a punter to wreck the bank. Blaine is not as stupid as the previous management.

Here is a question: Can you spot the bad logic? And further: Is it possible to win at 3 sixes with limited funds?

CARNIVAL IN SUNSHINE

Everyone is smiling, Bronski, who was, in theory, visiting from St. Petersburg, still found it a little difficult to understand. He was used to miserable faces in miserable queues, waiting for something, even nothing, probably more misery.

Here, it was a warm, early summer, day. Music was playing loudly from stacks of speakers placed on the stage just behind our view. Bronski was in the crowd; he was following someone as usual. He was attached to the Russian embassy in London, posing as a pop press hack, and had been on his current assignment for sixth months already. He would remain until completion.

He was assigned to watch and report all movements of the pop star Ilya Pushkin, who was touring Britain with his new band, Fallen Wall.

Ilya had been living and working in Britain since 1995, when he had left his motherland to become a British citizen. Unknown to the British authorities, Pushkin was an agent for Russian security, acting as a pop musician. Ilya's job was to infiltrate the British Pop World and find out as much as possible about its workings. Lately his career as a pop star had exploded out of all expectation. Ilya and his band were becoming world famous. As his fame grew his reports to Moscow became fewer; hence Bronski was despatched to keep an eye on him.

Bronski was middle aged and certainly not trim anymore; why was he chosen for the job? Initially he found it enormously difficult to convince the pop world that he was a 'bona fide' writer for the Moscow pop press. With much persistence, he eventually gained access to Ilya Pushkin's inner circle and mixed freely with him, his band, his music agent and his recording company.

In Russia, Ilya Pushkin and The Fallen Wall were becoming very big, thanks to Bronski's reports both to the Moscow pop press and his real employers. The Russian security force wanted Pushkin back on their terra firma. What better way than to organize a tour for him and his band. Bronski was charged with making the approach to Pushkin's management, on behalf of Russia's pop fraternity, to organize a grand tour of The Motherland.

Bronski is to make his move after this concert we witness today.

THE STAR

The Sun, our Sun, is a star; one of billions in our galaxy, one of trillions in the universe. Yet it is our Sun, our only Sun, keeping Earth warm and safe, maintaining life, as we know it, on this little planet.

A woman left Earth fifteen years ago. On Earth, three hundred and fifty years had passed since her take off. People on Earth were amazed at the return of someone from so long ago when space travel was relatively novel, though very advanced and possibly more interesting.

The woman, whom we shall name Jane, was extremely puzzled as she entered near Earth space. She was astounded at the numerous space stations and living platforms that had been built, in Earth orbit, since her departure 15 years ago. Jane hailed Earth on all radio frequencies, as was usual on return, to avoid being blown out of the sky by paranoid Americans. She, in turn, received over 500 messages in strange English and machine language, asking for her identity code.

Jane gave her space pilot's licence number. Earth immediately sent a probe craft to meet her. The probe, using machine language, indicated automatic docking was imminent. Five minutes later three space-suited people entered Jane's craft.

"Welcome back Jane Arnold, you have been away from Earth for three hundred and fifty years. We understand you have been lost in space, now we can amend our records."
"According to my chronometer I have been in space fifteen years and five days!" exclaimed Jane.
"That may be true for you, but Earth time says you have been travelling the cosmos for 350 years 23 days."

Jane was puzzled; her craft was super luminal, with the usual ability to travel outside time. It was not possible that she had been away so long! All such problems of relative time had been solved twenty years before she left Earth. Then, with sudden shock, she realized she would never see her family again!
"Don't worry", said the space probe captain, as they made their way down to Earth, "all your family are well and still alive. After you left immortality became available to all humans. Certain chemical compounds were released into the air, water and soil; as a consequence everyone alive at that time is alive now. You too will become immortal as soon as you land. Even as we speak your brother and sister are arriving at Earth Central Space Port to greet you."
The Sun, our star, still shines the same even after 350 years. Jane was never to discover why she had lost so much precious time; she was too busy making up for it.

A TRUE STORY

The "Five Sided Find" was found buried under the skeleton of a late Jurassic velociraptor. This was not possible, according to the experts; someone must have placed it there!

Now stored in a secure cell under the Pentagon, the find was an overnight sensation, quickly forgotten by the media when bullied by the Secret Service. "Jurassic Tecky" or "Raptor's Toy" as nicknamed by the press, was virtually wiped from credible memory. It was a hoax according to President Dorian of the United States of America. He had to say that. Why? I hear you ask!

Truly, the "Five Sided Find" did prove to be 120 million years old; it was a recording device containing invaluable knowledge of a super intelligent race who visited Earth all those years ago. Obviously the dinosaur had taken a fancy to the object and treasured it after eating the alien for dinner. After death the dinosaur became fossilised with the object lying under it for all

those years. It had not corroded or deteriorated in any way. The body of the device appeared to be made of ceramic, which is indestructible if left undisturbed, as it had been, only to be discovered 120 million years later by a team of Montana geologists looking for rare minerals in the Badlands.

The authorities considered the find too important for public consumption, instructed the CIA, MI6 and FBI to jump quickly and kill all knowledge of the device, swiftly as lightning. The three geologists received large payouts to deny the story they had told the press. A further incentive to keep them quiet came in the form of subtle threats to their respective families. The object was taken for study and passed though many secret establishments, before finally reaching the Pentagon basement.

The janitor unlocked the massive steel door; it took huge effort to push it open, the cell had remained sealed for 40 years. His orders were to throw all rubbish out and burn any papers he came across. Rubin, as he was known, went about the clearance slowly, he had all night and the room was not too full. Rubin assumed everything in the room was junk; he had no concern about what should be trashed, it was not his business. Five hours into the job he lifted a five-sided item. He was a clever man, never reached his full potential, but still a clever man. With his keen memory he recognised the object. 40 years ago the media had amazed the world by announcing the 120 million year old "black box", "Dino's Toy" etc.; soon to be heard of no more, except to be told it was a huge hoax.

Here was the original, the "Five Sided Find". The janitor finished his task, closed the door, put the object in his bag and left the building for home.

INTO THE NIGHT

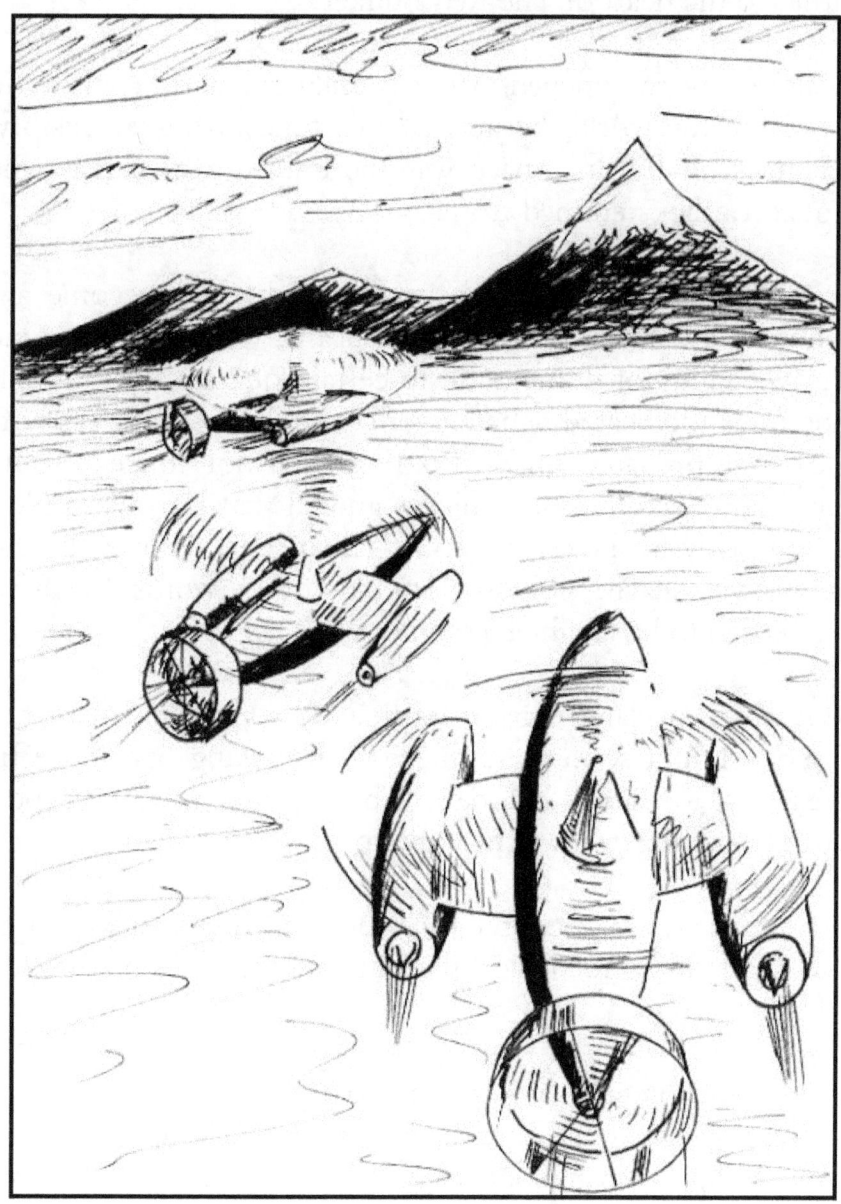

Over the city, into the night, three ultra-fast helijets carry top-secret personnel to a meeting fifty miles out of town. It was called at a moment's notice. The President, a woman of action, made her mind up as soon as the despatch reached her office. She put "Red" calls through to all military and appropriate departments. A Red call means conflict imminent unless the President says otherwise. High ranking military, national security services and top government scientists made haste to gather with the President at the Red Bunker; a place so secret that only the special services pilots knew its true location. The installation was five miles beneath the heart of a mountain. After smooth landings, the top secret personnel alighted; they began making their way calmly towards the 3 feet thick steel doors that were poised to close; once passed they glided together silently with exquisite

lightness; the complex was sealed. They were the first of many such doors on the journey to the heart of The Red Bunker.

Communications were opened to all military and civilian facilities worldwide. I say the world, because at this time in human history, there were no enemies on Earth. Space was the only threat; that is where the latest potential conflict stemmed from.

For many hundreds of years, since cosmic flight had become a regular feature of human life, aliens, known as Athicans, were constantly bickering with Earth over rights of domination in certain quarters of the Milky Way Galaxy. Such was the heated debate over controlling galactic resources that the Athicans were prepared for war, if Earth did not concede some of its gains in the Orion Sector. The Athicans argued that Earth was plundering this sector so heavily for raw materials, to enhance its empire, that little was left for their own galactic colonisation. In other words Earth was too greedy and, needed to be taught a lesson.

Finally the Athicans declared war on Earth and its Empire. At first this was not taken seriously but soon the Athicans were taking over huge tracts of space at great cost to Earth's colonies. The Athicans seemed to be able to destroy Earth technology with virtual impunity.

Although reluctant and worried, the president knew what she must do. She commanded the military to deploy the ultimate weapons at their disposal, whatever the cost.

The Athicans were literally blown from existence, their race wiped out totally by a weapon that was banned centuries ago. A device so dangerous that only 30 people throughout Earth's galactic colonies knew of its existence. The Total Resonance Disruptor was used to ultimate effect in the Athican War. Earth became the dominant power in the galaxy. Much sadness prevailed; many Earth people had become great friends with their Athican rivals. It was a great loss to the culture of the Milky Way that such drastic measures had to be taken.

A STRANGE STORY

The expedition came to a halt, a frozen halt! Each of the team of ten stood looking ahead, mouths wide open, eyes popping out of their heads. Writing was on the wall in letters ten feet tall, covering the entire cliff face from ground upwards, to a height of three hundred metres.

One minute jungle, the next, an immense wall of cold, perfectly smooth granite, towering forever, inscribed with what appeared to be Greek. The linguist of the group came alive first, making an attempt to read the huge letters. She said it was like no Greek she had ever come across; it was so archaic, made no sense, unless it was another language using a Cyrillic script such as Russia had adopted. The team regained some their composure as the linguist started talking. Yet they were still overawed by what she said.

The Peruvian jungle was still mostly unexplored. This so called Greek Wall was not supposed to be there; the whole archaeological fraternity was in uproar, such was the controversy caused. Who carved the nine-thousand-year old characters? What language was this that used Greek lettering, 6,000 years before the real Greeks did? And why was this found in South America?

UNTITLED

The elephants strolled along two by two. One was pink, another blue, two were green, three were yellow and one white. In all, the eight creatures looked wonderful as they ambled down the golden highway to their happy home in the great southern forest. To the north, where the Greeks lived, golden domes reflected the late afternoon sun. From the eastern horizon, a squadron of flying saucers slowly approached the airfield where I stood.

I was about to leave my home planet and head out to the stars. My flight was three hours late and, to my great annoyance, subsequently cancelled. Luckily, I had been transferred and given a berth on a merchant trader's giant gleaming ship that had just landed. The captain of the ship was a small man with big head, calling himself Horatio Hansom of the Stars and Galactic Domains; an exotic name for such an unassuming individual. I had no choice but to take up the transfer; it would mean a three-year wait until the next available craft otherwise.

Velociconica, in the Andromeda Quarter on the periphery of space, was my distant destination. A vast distance, but such exciting prospects. The flight took three standard Earth weeks. My cabin was respectfully comfortable and well appointed with an astounding viewing facility. These space merchants certainly looked after themselves and all on board. I could not have fared better on my cancelled flight.

The reason for my visit to Velociconica is three fold; firstly, it is the frontier, unknown and novel; secondly, riches are to be made and, thirdly, I liked the name. Actually the true reason for my trip is that Central Government for all Stars and Worlds has commissioned me to make a docudrama video of Velociconica; its life, its times etc. etc., the usual. The unusual: I have been told to pay special attention to the "mind people". Apparently, strong telepathic capability is supposed to have descended on a high proportion of early settlers, evolving into the establishment of a new religion, which is spreading through the outer galaxies. Obviously the Central Government for all Stars and Worlds is concerned that Its rigid control over the known universe may well be under threat.

I was met at the Velociconica Space Field by three very tall people. They looked like men, they may have been women; they may be I don't know what! They asked me a few questions, and politely suggested that I may not have any business on this planet…

THE BLACK PYRAMID

"Small is large." said Smyth, leader of the search for extra-terrestrial archaeology. "Yeah," he went on, "this is the most significant object so far discovered on Mars that has obviously been created by intelligent beings."
"How do you know it was made by aliens; humans could have planted it?" demanded Jones of the Press Corps.
"Like I said, small is large; watch, your question will be answered." Professor Smyth picked up the small black pyramid, pressed one side and, as if by magic, it doubled in size. He pressed another side; it doubled again. The audience went wild; surely this was not human technology?

Jones was not taken in; he was not only a journalist, he was a member of the Secret Order of White Magicians. He knew a few tricks and, clearly, this could be one.

After the lecture on recent Martian discoveries was over, Jones, who had hidden behind a curtain, revealed himself to Smyth, who was busy packing his lecture paraphernalia away.

"Fine show Smyth! How did you do it?"

Smyth jumped, startled by the voice disturbing his daydreaming, whilst putting the black pyramid back in a sturdy case. "What do you want Jones?"

"You know that's all fakery; any second rate conjurer could pull that pyramid trick off."

"OK smartarse, you do it then!" exclaimed Smyth.

This is just what Jones wanted; a chance to look at the black pyramid close up. It was heavy, very heavy. Jones could not lift it. "I can't move it!" he flustered.

"Of course not! You do not believe it is anything other than a fakir's toy. It won't work for you!"

"Why won't it work for me?"

"I know your secret Jones. You are not a real magician, you're an illusionist, and therefore believe all you see is an illusion. You cannot make the pyramid work because it only functions for those who approach it with an open mind. Now, if you had discovered this object, as I did, and with my kind of approach, it would cooperate with you and, what's more, you could lift it with ease."

"How did you reduce its size?" Jones continued to quiz.

"Simple, I told it to become small. And it did!"

"This still does not prove the object to be of alien origin?"

"Oh come, come, man," replied Smyth, "how many humans have been on Mars? And, what's more, how many humans have done archaeology on that planet? Only me, and I could not possibly make an object like this! Could I?"

A RICH TALE

On the 25th floor, a man was standing looking out of a large window. He was not in an office; he was at home. Two years ago, he bought the whole building for 45 million Dollars. He thought it cheap for such a prestigious location in Downtown, New York; it was now worth 73 to 75 million.

Six months after acquiring the wedge shaped building, Mr Brick moved into the fully converted 25th floor super apartment comprising of: two state rooms, one bedroom, no guest room, one kitchen, one very large bathroom, one dressing room and a huge studio. Down one level on the 24th, Mr Brick installed a single, massive, swimming pool, which extended through the whole storey, conforming to the triangular shape of the building

Mr Brick enjoyed working in his studio; he was an electric designer, or cyber artist, to the electronic games trade. During the 1970s and 80s he was in much demand and by 1985 he had designed some of the world's best known computer games. He became a Dollar billionaire. By 1995 Mr Brick had retired from cyber game construction, and had taken up sculpting. His chosen medium was clay; already within two years his work was displayed in a major New York gallery. By 1999, his fame was international, achieving worldwide renown as a Sci-Fi Ceramicist.

He stood looking from 25 floors above the roar of Fifth Avenue traffic; the triple glazed windows ensured perfect peace, the air-conditioning ensured perfect atmosphere, life could not be better.

The telephone rang, not his mobile, so it meant business. Action Movie Corporation wanted to hire Mr Brick to design and direct a Sci-Fi, computer-animated saga about a family lost in space, and all their exciting adventures. Mr Brick said NO, unless he was paid one Dollar for every second his work would be shown in cinemas and broadcast to homes throughout the world.

Action Movie Corps agreed. Mr Brick would become unbelievably rich; he would buy New Mexico…life could be better, much better.

A DULL NEWS DAY

The five thousand mile an hour plane....

It flew over Birmingham at low level, several buildings were severely damaged; one lady lost her hat, a man lost his toupee.

Tuesday was not an easy day at the press office; no news was the news; no callers; no international events, loads of nothing happening.

Wham...the roof fell in, no one hurt, dust everywhere. I looked into the open sky; a weird craft was flying away to the north at unprecedented speed, sonic booms in its wake.

Well, we had our story but nothing to write it on, every computer was destroyed in the ruin of an office. It started to rain and hail then lightning, thunder and wind; lots of it! All staff moved to the safety of the closed down school across the road. Someone handed round coffee with biscuits.

It was Jim, the handy man, always at his handiest in times of crisis. Jim happened to be outside and witnessed the whole event. We used him as one of our scoop witnesses. Three other people had been pulled in off the street and offered big money if they gave us their accounts of the mystery aircraft debacle.

The gist of the event is as follows: From the south a black shape approached, seemingly slowly at first, then a huge acceleration to thousands of miles an hour, thus causing damage to buildings and much inconvenience pedestrians. No one was seriously hurt; only property - mostly windows - but several offices were ruined, including our own pressroom, which was a one-storey building. Luckily our printing and publishing workshop was untouched. The team had to set the newspaper in the old-fashioned, labour intensive way, without computers. Fifteen thousand copies of a small-format daily were run off for immediate circulation around Birmingham.

Five hours later the black aircraft returned, stopping dead over our temporary shelter in the old school house; we tumbled outside into the now clear day. Someone opened a window, looked down and waved to us from 50 feet up. Clearly seen, a man in uniform was laughing and joking with others in the craft. He shouted something in a foreign language, waved again and closed his window as the craft sped away causing more damage east of the city.

Now we had the next instalment of our weird flying craft story. No press office, but we had gained a super headline, which sold to all corners of the globe. An exclusive story and, more importantly, excellent photos, taken by two of our best snappers using large and medium format cameras. One shot was sold to an American news magazine for 5 million Dollars. Not a bad bonus on a dull news day.

A DOOR IN A WALL

A solid, raw oak door; set in a brick wall. At over 6 feet the wall was too high for me to look over. However, I knew what was on the other side. At least I thought I did.

25 years ago, I had been invited to a party in the grounds of Lord Snoot's manor house. It was a celebration of 30 years of dedicated research into why it is harder to push a length of string than pull it. Lord Snoot was very proud of his up-to-date research facility in the south wing of Lucky Manor, his ancestral home that had been in the Snoot family for at least 3000 years.

The reason for my attendance at Snoot's party 25 years ago was that, at that time, I was head of his computer division, leader of a team at the sharp edge of technology. We had started, thirty years earlier, on the final drive of what

was to become "Snoot's Law". That is, "The length of string is inversely proportional to the effort required to push it."

After 30 years of intense labour the world recognised this great scientific breakthrough for the mind blowing potential that pushing string could offer world commerce. The theory and practice of string pushing took on new meaning.

My work was completed on the day of that party. So myself, and the rest of the computer team, were dismissed with handsome payoffs. So handsome, we need never work again.

And now I was walking past Lord Snoot's estate once more, passing the same oak door in the wall I had used every day to get to and from my work in the computer department. I thought I would look in, and see how old Snoot was doing. I pushed the door; it was stiff, needed some shoulder, but eventually gave access to the garden. What met my eyes left me speechless. I could not believe what had happened to Snoot's Lucky Manor House, let alone the beautiful grounds where we used to have our lunchtime picnics. I was so baffled, I went home without closing the door behind me. Three other people, I vaguely remembered, entered the estate as I left; I wonder what they thought of the place? It was months before I recovered from the shock; I'll never be the same again.

FAREWELL

STOP RUN.

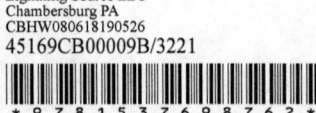

www.ingramcontent.com/pod-product-compliance
Lightning Source LLC
Chambersburg PA
CBHW080618190526
45169CB00009B/3221